THEN & NOW

GILES COUNTY

Opposite: The Cascades waterfall on Little Stony Creek is one of the many beautiful natural sites for which Giles County is known. The 2-mile round-trip hike has long been a favorite of visitors from miles around who follow the picturesque trail along the creek to the breathtaking 66-foot waterfall. (Giles County Historical Society.)

GILES COUNTY

Terri L. Fisher

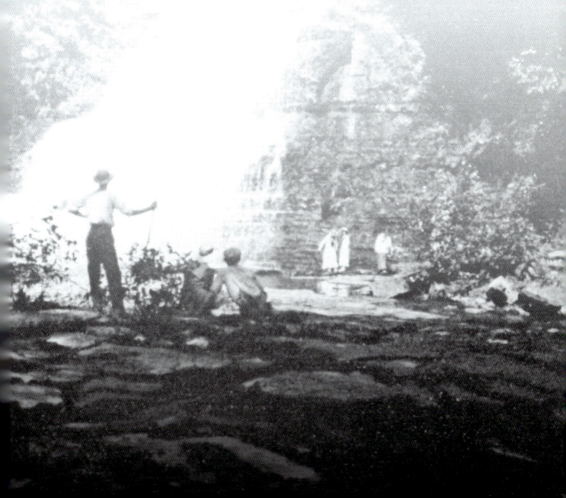

To Terry: For your willingness to drive the roads and hike the trails of Giles County in search of the perfect "now" photograph.

Copyright © 2011 by Terri L. Fisher
ISBN 978-0-7385-8716-5

Library of Congress Control Number: 2010934412

Published by Arcadia Publishing
Charleston, South Carolina

Printed in the United States of America

For all general information, please contact Arcadia Publishing:
Telephone 843-853-2070
Fax 843-853-0044
E-mail sales@arcadiapublishing.com
For customer service and orders:
Toll-Free 1-888-313-2665

Visit us on the Internet at www.arcadiapublishing.com

On the Front Cover: Mountain Lake Hotel has been a popular resort in Giles County since the first hotel was built in 1856. The lodging has grown and changed over the years, but people still enjoy relaxation, recreation, hiking, and other outdoor pursuits at the highest freshwater lake east of the Mississippi River. (Then, Giles County Historical Society; now, author.)

On the Back Cover: The many communities of Giles County had their own commerce centers with stores, banks, mills, and post offices. This scene on Snidow Street in Pembroke of the John Williams Store around 1910 is typical of the pride felt by the owners and builders of a new business in a community. (Giles County Historical Society.)

Contents

Acknowledgments vii

Introduction ix

1. Eastern Giles: Newport to Pembroke 11
2. Central Giles: Pearisburg to Poplar Hill 27
3. Western Giles: Narrows to Glen Lyn 47
4. Mountain Lake Hotel: Resort Getaway 61
5. Homes: Lost and Found 73
6. Industry: From Mills to Factories 81
7. Bridges: Crossing Water 87

Acknowledgments

I owe a debt of gratitude to everyone who helped me find the historic photographs for this book and then determine the vantage points for the "now" photographs. This project turned out to be more difficult than expected in our rural area mostly due to good old Mother Nature. My husband joked that every time someone took at photograph in the early part of the 20th century, they dropped a seed that has today grown to be a large, leafy tree completely blocking the view that was once there! Between the trees and finding the buildings that I thought sure I knew where they were, the project was interesting and a challenge for those of us who pride ourselves on being observant!

Thank you to J. T. Frazier (JTF), Pam Kantsios from the town of Rich Creek (RC), Sheryl Lyles of the U.S. Forest Service (USFS), Doug Martin (DM), C. G. Thomas (CGT), Marilyn Thompson (MT), and Estelle Woodbury (EW), who generously provided historic photographs from their collections. Several of the older bridge photographs are from the Library of Congress, Prints and Photographs Division, Historic American Engineering Record (HAER VA-126 and HAER VA,36-PEMB.V). Abbreviations following names are used to identify photograph owners in the captions.

Thank you to Araby Nicholson for helping me to locate historic photographs at the Giles County Historical Society (GCHS) that had not been used in the *Pearisburg and Giles County* book. Thank you to those who helped me identify those with historic photographs and where the buildings were located in the historic photographs—Bonnie Butler, Greg and Angie Frazier, Eddie Kendall, and Temple Lawrence. Thank you to Elizabeth Bray at Arcadia Publishing for keeping me on track.

Except for one photograph at Glen Alton taken by Sheryl Lyles, I took all of the "now" photographs myself but could not have done that without my chauffeur and husband, Terry Nicholson, who drove and walked all over the county with me during every daylight hour of free time we had to find the locations in the "then" photographs. Thank you for your patience and sense of adventure!

As always, the Giles County Historical Society would love to enhance our collection of old photographs; the information contained in them is so important for remembering the past. If you have old photographs, or know someone who does, consider letting the historical society scan them for our collections.

Introduction

Giles County's communities are as unique and varied as its landscape. Pearisburg, incorporated in 1808, is the county seat and focused on the services of government. Newport was a crossroads town for stagecoaches. Eggleston was a springs resort and later an important railroad town. Kimballton developed around the lime deposits and their potential for agriculture. Interior became a train stop for hauling timber out of the mountains. Narrows' location where Wolf Creek empties into the New River provided many opportunities for water-powered mills. Agriculture has flourished in many communities where the rich silt from the New River aids crops.

Transportation has been a challenge in Giles County due to the rivers, creeks, and mountains. Fords, ferries, and bridges crossed the waterways. Stagecoaches braved the mountain roads with passengers moving west or tourists visiting places such as Eggleston Springs Resort and Mountain Lake Hotel. At least four different railroads, their owners seeking the money in coal, timber, and other natural resources, followed the relatively level rivers and creeks of the county.

Natural resources attracted industry as well, providing an important economic driver for the development of Giles County. Glen Lyn grew around the Appalachian Power plant situated on the New River. Narrows and Pearisburg expanded exponentially when Celanese Corporation built a factory between the two towns. Bluff City developed around the New River Tannery. Populations in Ripplemead, Kimballton, and Pembroke all increased as a result of limestone quarries.

The reasons for growth in the communities of Giles County have contributed to changes in these places over the years. As transportation improved, people could drive themselves to larger commercial centers to shop. U.S. 460, which used to bisect the county, passing through the center of towns like Newport, Pembroke, Ripplemead, and Pearisburg, now bypasses them entirely. Trains no longer stop at depots and small communities along the New River. Most of the limestone quarrying operations are gone now, as are the tanneries. Celanese Corporation, while still the largest employer in the county, now has about one-quarter the number of workers it once did. The result of these industrial changes is that many of the commercial centers are quiet or struggling. Many homes are not as grand as they once were or were lost with the widening of U.S. 460.

As always, the people of Giles County are resilient. Narrows and Pearisburg are both undergoing downtown revitalizations. Newport and Eggleston are seeing a resurgence of population and interest in older residences as faculty and employees from Virginia Tech move westward. The new eco-friendly industrial park near Hoges Chapel is attracting business and employees to a former farm. Historically agricultural White Gate has attracted a new Amish population that is becoming known for its log buildings and furniture making. Tourism is growing as an economic driver for the county, with kayaking, fishing, and hiking as the main attractions, bringing with them complementary businesses. No place is ever stagnant. Giles County and its many communities will continue to evolve to meet the demands of the 21st century.

Chapter 1

EASTERN GILES
Newport to Pembroke

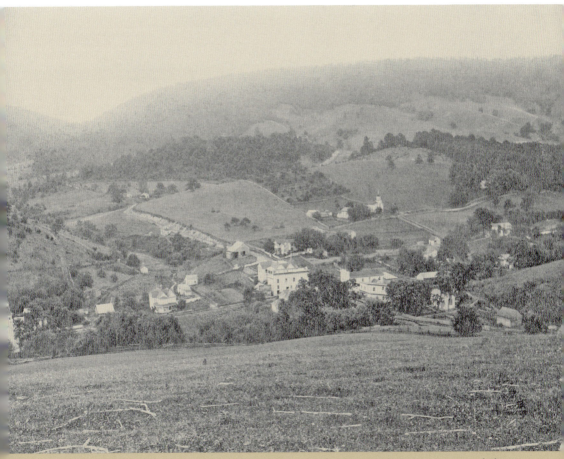

A view of Newport shows the typical hills and farmland of Giles County. To the left is Newport Mount Olivet Methodist Church on today's Route 42. Hunter Hotel and Miller Brothers General Merchandise Store can be seen at center, with the F. E. Dunklee Store at right marking the intersection of Route 42 and old Route 460. (DM.)

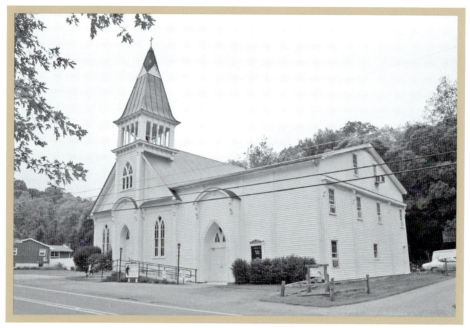

The Newport Methodist Church was organized in 1850 with the building constructed several years later. Today known as the Newport Mount Olivet Methodist Church, the congregation includes those from two other churches. The Mount Olivet Methodist Church, east of Newport, organized in 1897 and merged with the Newport church in 1975. The New Zion congregation formed around 1850 and merged with the Newport church in 1969. Today Newport Mount Olivet Methodist Church on Route 42 has over 170 members. (DM.)

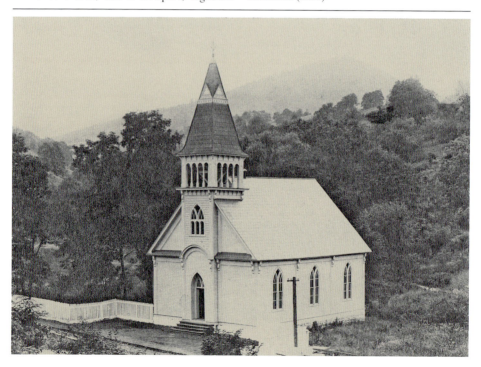

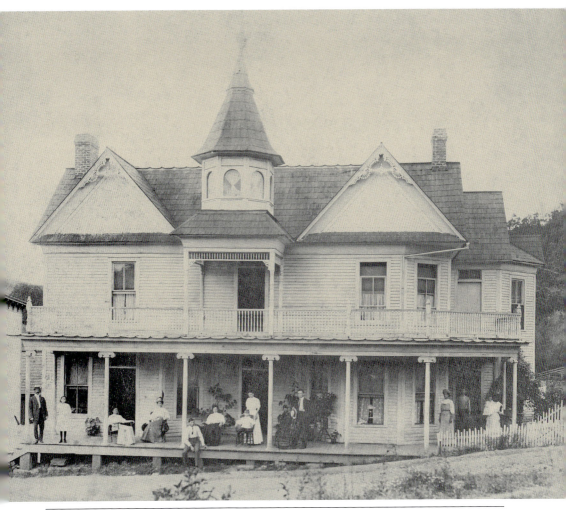

Located in the center of Newport, the Hunter Hotel was built to replace Hunter House, which burned in the devastating fire that leveled much of downtown in 1902. The hotel later became the Newport Inn and was a popular spot before automobiles became the preferred mode of travel. Rented for many years as apartments, the building has recently been restored. (DM.)

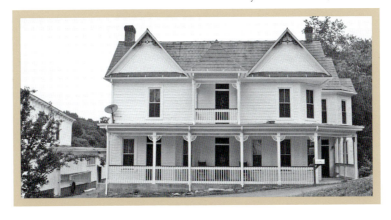

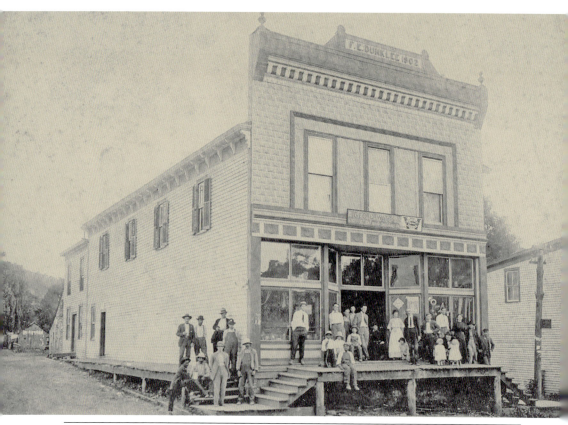

The F. E. Dunklee Store was built in Newport in 1902, soon after a catastrophic fire leveled much of the town. At the intersection of the roads that would become U.S. 460 and Route 42, the business was at a prominent location. In the 1960s, U.S. 460 bypassed Newport, hastening the closure of the remaining stores. Though shuttered now, the Dunklee Store is still a prominent landmark for those traveling on Route 42. (DM.)

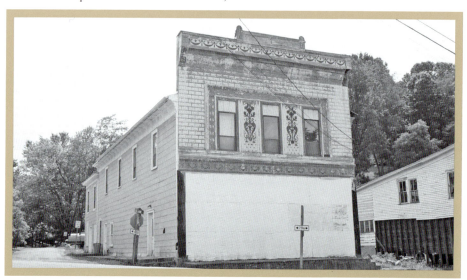

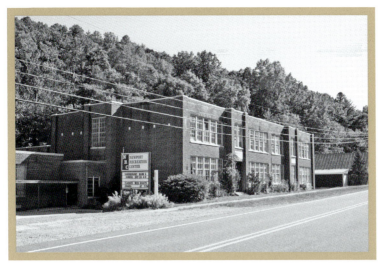

Newport High School was built by the Works Progress Administration (WPA) in 1933. When Giles High School was built in 1961, Newport students moved to the new school in Pearisburg. The old school was used by elementary students until Eastern Elementary School was built in 1982. Today the old Newport High School is used as the Newport Community Center and is also home to the Newport Fair, the oldest agricultural exhibition in Virginia, held each August. (GCHS.)

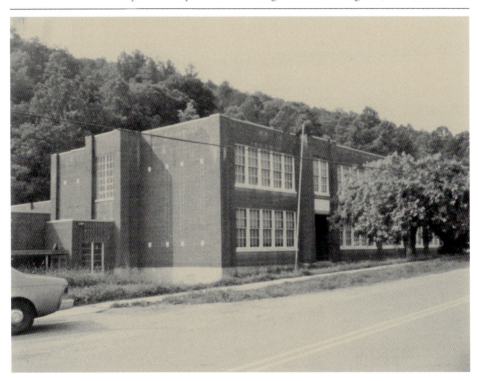

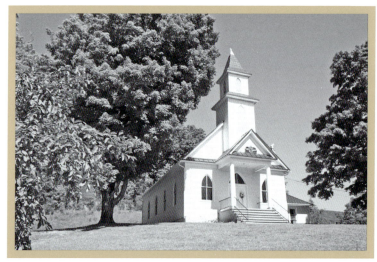

Sherry Memorial Christian Church was built in 1903 on Route 700, Mountain Lake Road. The church was constructed as a memorial by the family and friends of James Sheridan Porterfield, who lost his life in a sawmill accident in 1902. High on a hill above the road, the structure has a commanding view of the mountains. Its congregation is still active today. (GCHS.)

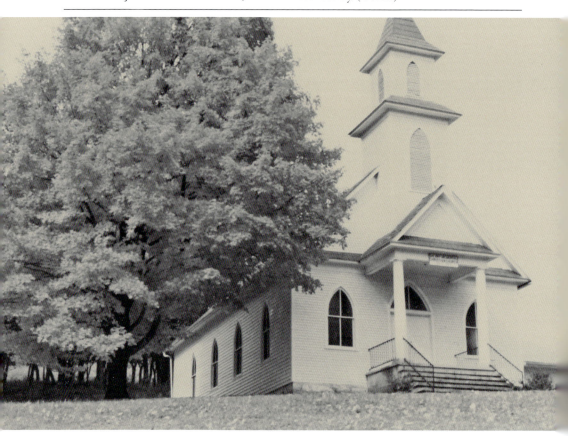

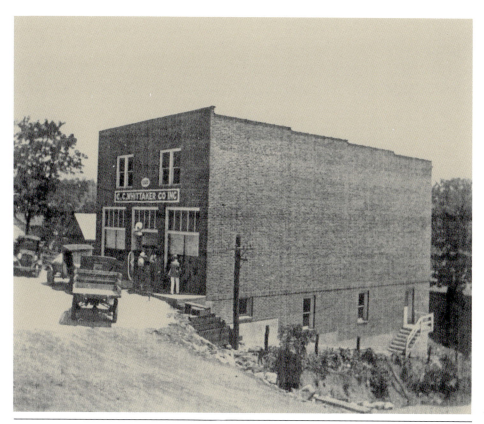

The C. C. Whittaker store was built in 1926, when Eggleston was bustling as a commercial center for the eastern part of Giles County, and was later expanded to include a Chevrolet dealership. The Pyne family ran the store for over 60 years, until 2000. Eggleston is again a destination, and the mercantile's new life as the Palisades Restaurant is drawing in visitors from miles around to enjoy the quiet setting on the New River. (EW.)

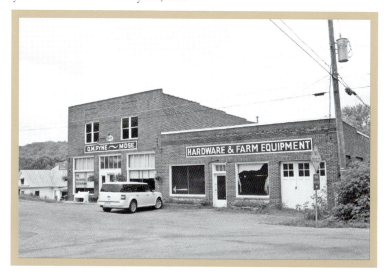

The People's Bank of Giles County was located on Village Street in Eggleston, near today's Palisades Restaurant. The bank was one of many businesses, including general stores, a jewelry store, an ice cream parlor, a shoe repair shop, a millinery shop, and holiday houses along this street, which led to the old bridge across the New River. The bank failed during the Depression and became a private residence. (GCHS.)

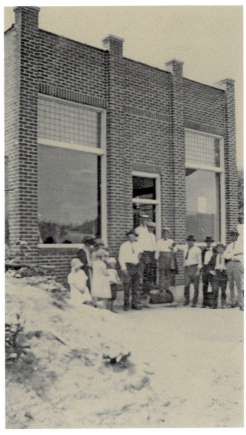

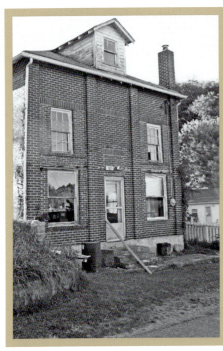

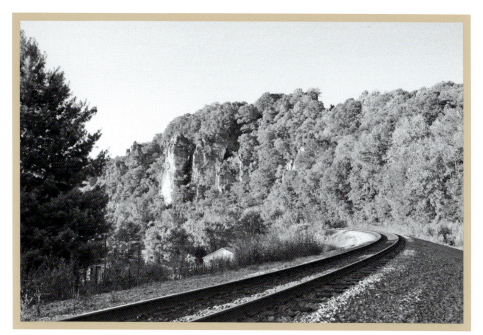

Limestone cliffs along the railroad at Eggleston are typical of the views along the New River in Giles County. Cliffs on the western side of the river created bottlenecks to Norfolk and Western Railroad construction in the 1880s, causing Eggleston to be known as Stay Tide. The Virginian Railway opened on the eastern side of the river in 1909, forcing the Eggleston Springs Hotel to move further from the waterway to distance guests from the noise and dirt of the coal trains. (GCHS.)

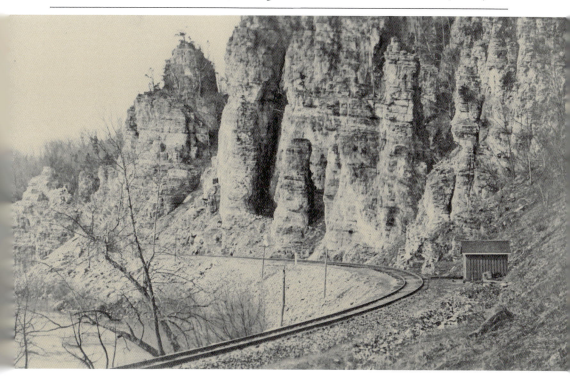

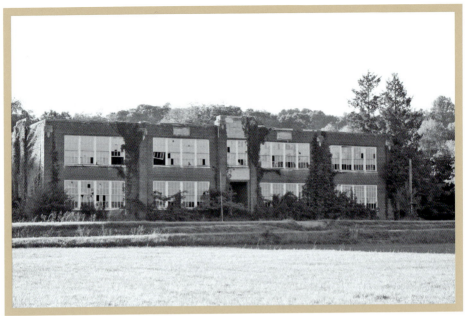

A photograph from the 1959 *Eggleston Echo* yearbook shows Eggleston High School just two years before Giles High School opened, consolidating high schools in the eastern and central parts of the county. The school remained open as an elementary school until 1982 and later was used by the Samax sewing company. Though still a solid brick building, the school is now showing the effects of being vacant for many years. (GCHS.)

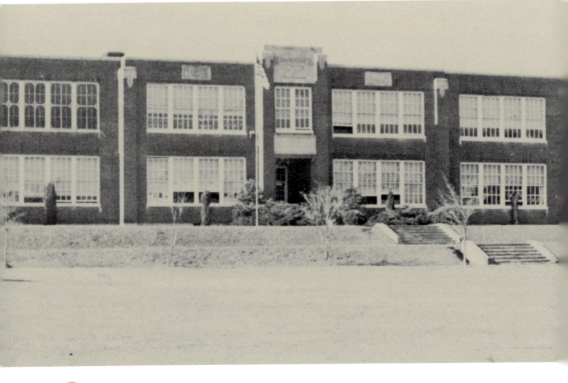

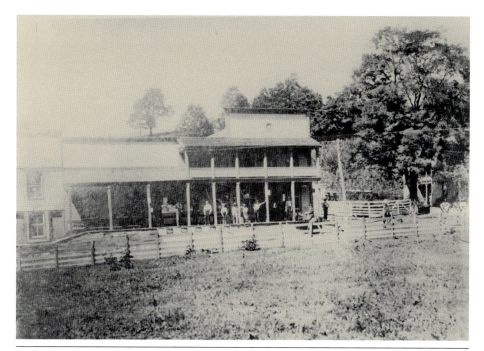

The J. F. Williams Store was built on Snidow Street in Pembroke in 1900. The store, to the right, burned in 1947, while the Williams house, to the left of the store, was removed when U.S. 460 was routed to its present location in 1957. All that exists today where these buildings once stood is a parking lot across the street from Giles Carpet Sales. (GCHS.)

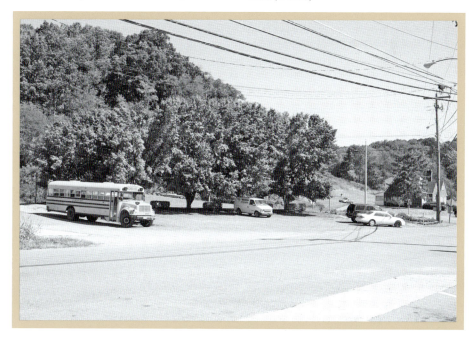

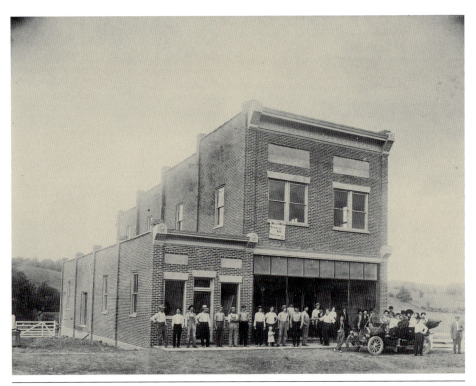

The store shelves and the second-floor windows are empty, indicating that the John Williams Store in Pembroke has only recently been built in this photograph from the early 1910s. The sign on the second floor says "Morris C. Miller Contractor/Builder Christiansburg, VA." The building facades and rooflines have changed, but the Amish Furniture store clearly occupies the old John Williams Store today. (GCHS.)

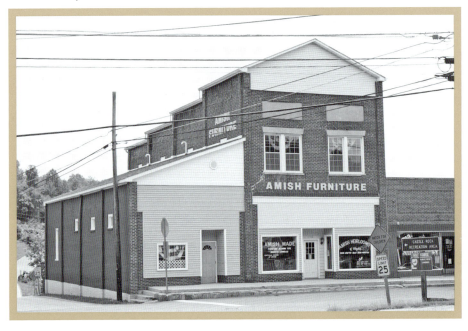

Pembroke Lutheran Memorial Church on Snidow Street was built in 1855 by George Snidow Jr. and Marshall Rice. Constructed with a frame of oak timber, the ceiling of the church is covered with tin tiles made prior to the Civil War. Much of the congregation transferred to the Redeemer Lutheran Church in Pearisburg in 1959. The church building is now privately owned and used as a residence. (GCHS.)

The old Pembroke Methodist Church faced Snidow Street when that was the main road through town. After U.S. 460 was widened and moved, a new brick Methodist church was built facing the new highway. The fellowship building now occupies the site of the old sanctuary on Snidow Street. Two houses to the left in the photograph remain. (GCHS.)

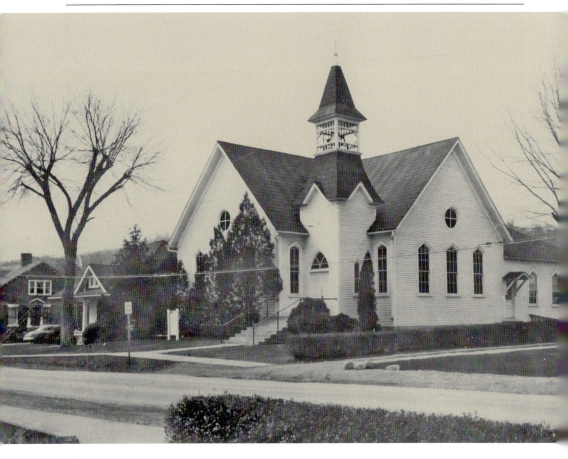

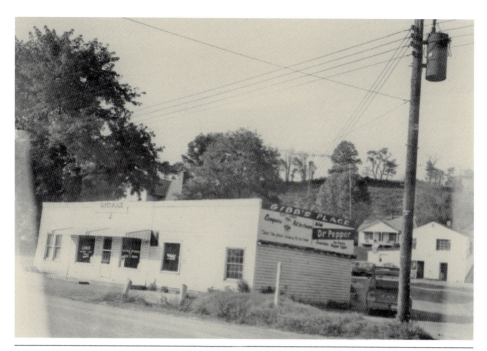

Gibb's Place was a popular hangout on U.S. 460 in Pembroke featuring Pet ice cream, Dr. Pepper, plate lunches, candy, and tobacco. Signs on the windows also advertise electrical appliances and TV sales and service, making this a rather eclectic destination. The Hairport is located here today. The house in the background beyond the Gibb's Place sign can be seen in the center background of the present-day photograph. (GCHS.)

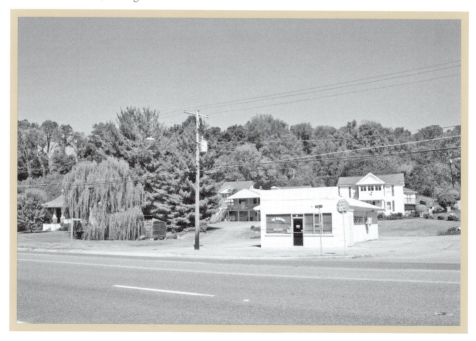

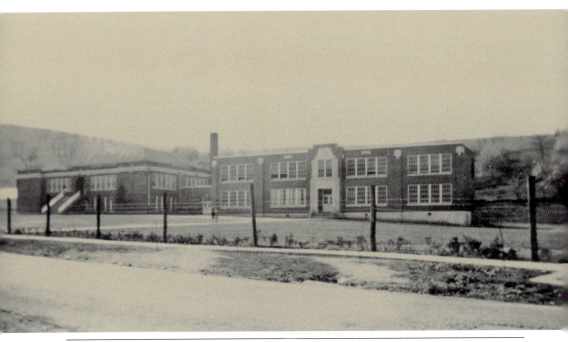

Pembroke High School, built in 1927, is shown in this photograph from the 1941 *Horse Shoe* yearbook. A second building, with a gymnasium, was constructed in 1938. High school students moved to Giles High School in 1961, while elementary school students relocated to Eastern Elementary School in 1982. The building is now S. A. Robinson Apartments for low-income senior citizens. (GCHS.)

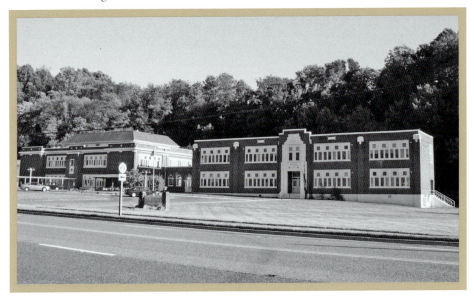

CHAPTER 2

CENTRAL GILES
PEARISBURG TO POPLAR HILL

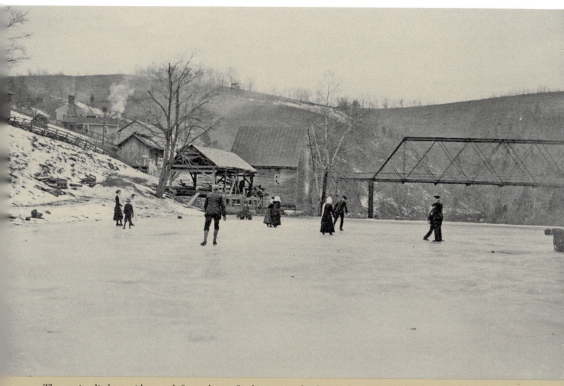

There is little evidence left today of this Staffordsville scene. The dam has been removed, leaving no mill pond for today's skaters. The mill, iron bridge, and many of the other structures are gone as well. (GCHS.)

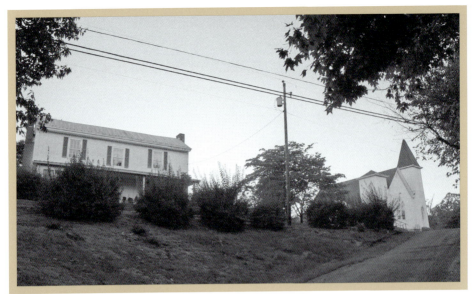

This photograph of Staffordsville in the 1950s shows the Dr. Hoge Stafford residence at left and the Sheffey Memorial United Methodist Church at right. The church is named for Robert Sayers Sheffey, an evangelical Methodist circuit rider. The power of Sheffey's prayers was legendary and helped to ensure him a place in Appalachian folklore after his death in 1902. (GCHS.)

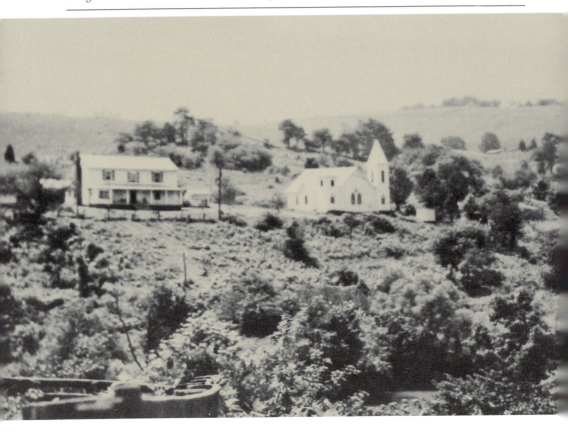

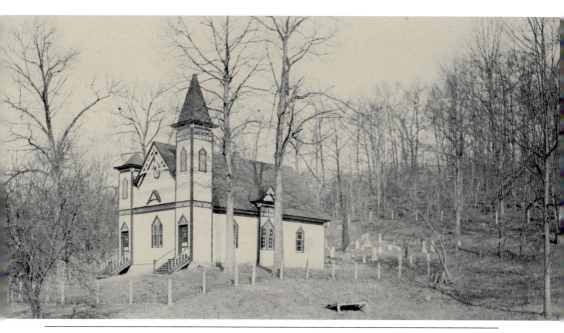

Eaton's Chapel Church in Staffordsville first held services in 1851 in a log meetinghouse on land bought from David Eaton at the site of the present church. The church was one of the first on the Staffordsville Circuit, which was created in 1879. The current structure was built in 1898. Eaton's Chapel is picturesquely placed on a hill with a cemetery surrounding it and offers a beautiful view through the valley. It still has an active congregation today. (GCHS.)

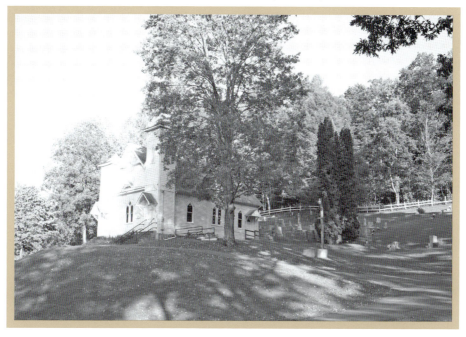

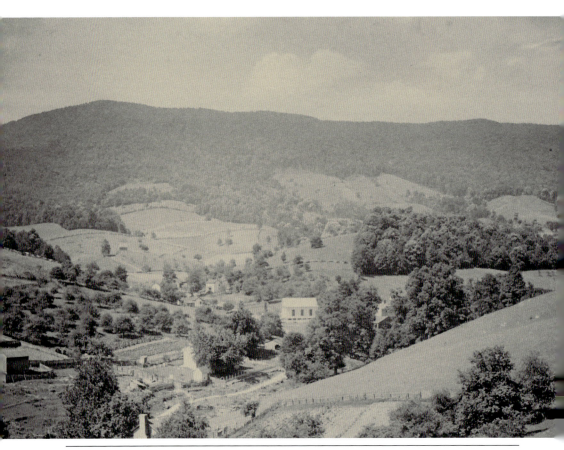

This bucolic view of farms and mountains is typical of the rural areas of Giles County. Not quite the same view, but in the same general area, the older photograph shows Thessalia, with the Thessalia United Methodist Church, built in 1880, at center. The present photograph shows the view from Eaton's Chapel Church in Staffordsville. A person can imagine people driving horses and buggies up the road to attend church. (GCHS.)

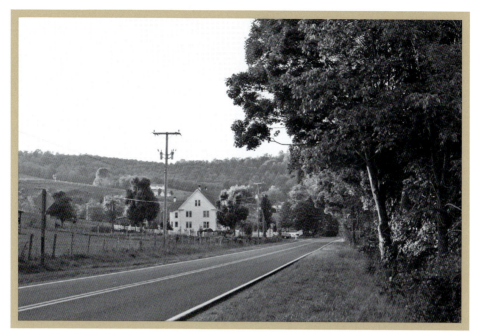

A view of Poplar Hill shows Route 100, Pulaski Turnpike, moving horizontally across the photograph and intersecting with Route 42, Holston Turnpike. The house to the left was the home of Samuel and Alice Gish Shannon and was built in 1899. Alice Shannon taught at the Walker's Creek District School, in a two-story building located just up Route 42 with the school on the first floor and a Masonic lodge on the second. The Shannon house remains on Route 100 today. (GCHS.)

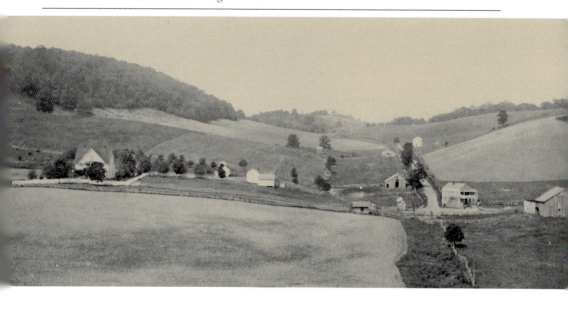

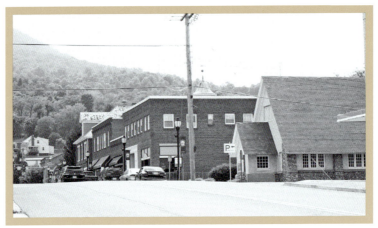

The photograph most commonly used to portray historic Pearisburg and Giles County is difficult to recreate today. When this unknown woman approached the courthouse via Wenonah Avenue, she did so in an agricultural landscape. Today buildings supporting commerce, county government, and the Episcopal church block the view from Wenonah Avenue of all but the cupola of the courthouse. The agriculture that was once part of downtown Pearisburg has moved to less populated parts of the county. (GCHS.)

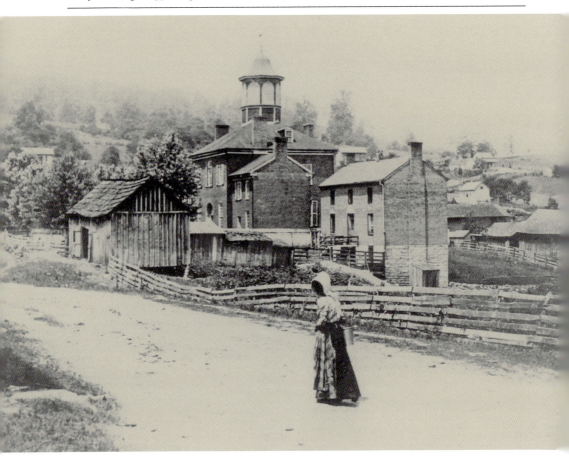

CENTRAL GILES: PEARISBURG TO POPLAR HILL

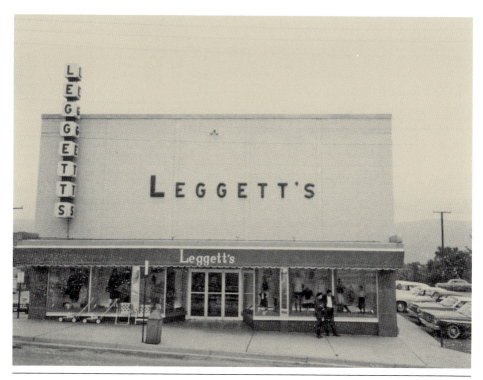

Leggett's department stores were once found in many small towns in Southwest Virginia and offered everything from lawn chairs to clothing to lawn mowers. As they were often in prominent locations, towns found creative ways to use the buildings after the stores closed. Pearisburg's Leggett's on Wenonah Avenue now houses Giles Housing and Development Corporation offices as well as apartments. (GCHS.)

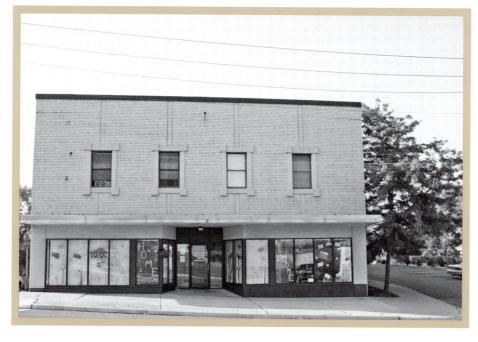

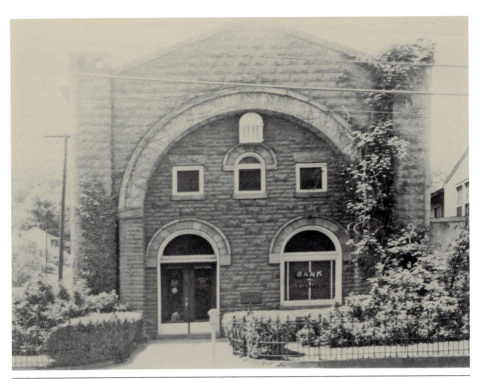

Pearisburg has had a bank since the 1850s. Collectors today find bills signed by the Old Dominion Bank in Pearisburg. From the early 1900s, the First National Bank of Pearisburg was located across Main Street from the courthouse in the structure shown. Today the building has been repurposed and is home to The Bank Food and Drink, a restaurant using local and organic ingredients. (GCHS.)

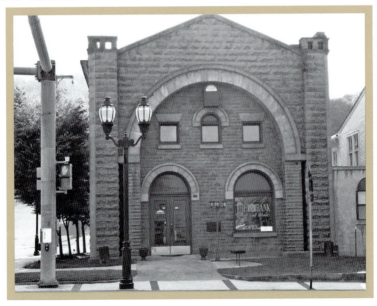

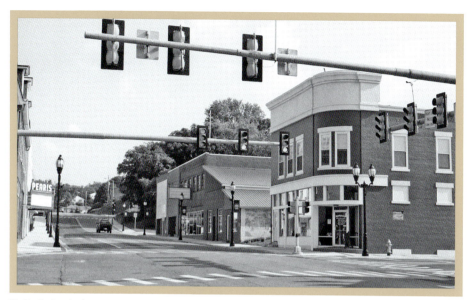

H. B. Shelton's department store was established in 1908 at the corner of Main Street and Wenonah Avenue in Pearisburg. The third story of the building was lost to fire when the Woolwine house next door burned in the 1950s. Now the building contains Marsha's Restaurant on the first floor and apartments above. The commercial structures further up Main Street replaced the Central Hotel and Savoy Hotel, both built in the 1800s. (GCHS.)

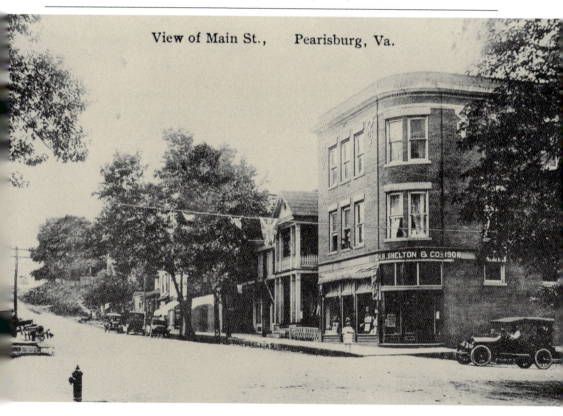

CENTRAL GILES: PEARISBURG TO POPLAR HILL

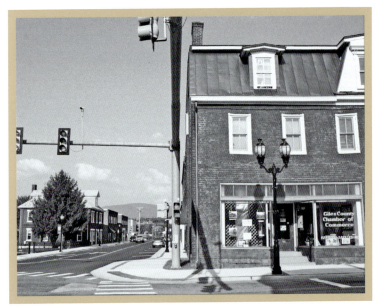

A worker rather precariously perches on the electrical lines at the corner of Main Street and Wenonah Avenue in Pearisburg in the 1960s in a manner that would be frowned upon by the Occupational Safety and Health Administration today. The Thomas building facade on the right was renovated in 2007, staining the brick to its previous color of red. The corner storefront of the Thomas building is now home to the Giles County Chamber of Commerce. (GCHS.)

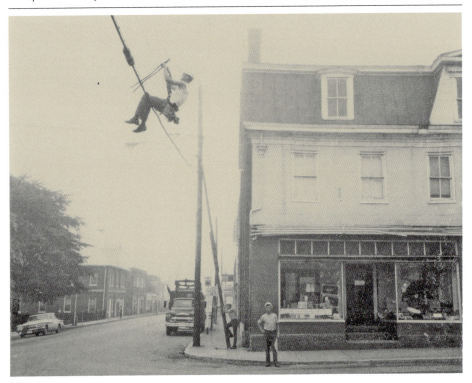

CENTRAL GILES: PEARISBURG TO POPLAR HILL

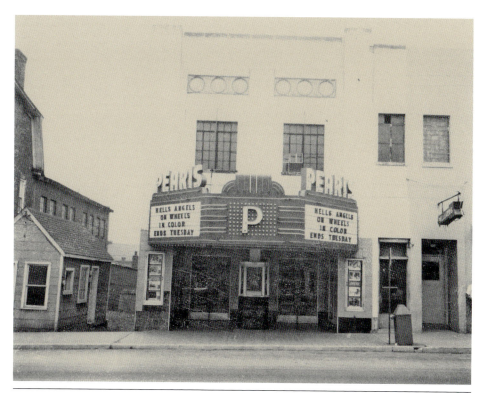

The Pearis Theater, built by the Star Amusement Company, opened in 1939 on Main Street in Pearisburg. The theater, managed by Jack Reel, was designed in an art deco style and played all of the popular movies of the day. While the marquee remains intact, the theater has been damaged by incompatible uses over the years. A citizens group is working to restore the Pearis Theater, which is used periodically for events today. (GCHS.)

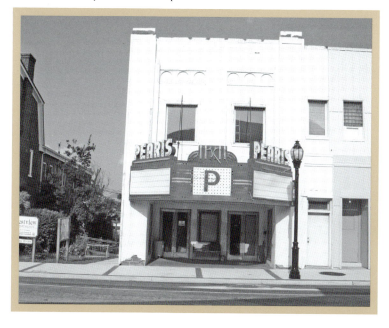

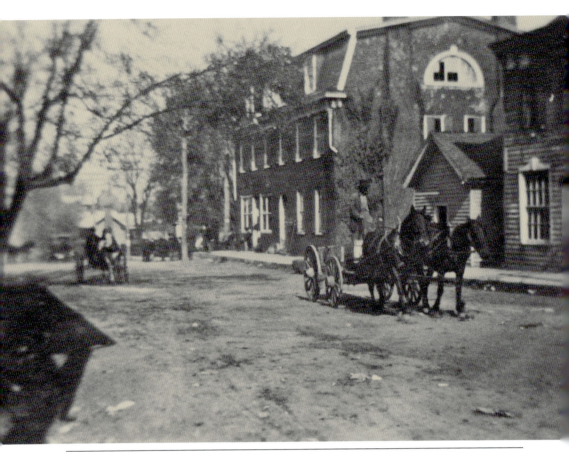

At the intersection of Main Street and Wenonah Avenue in Pearisburg, the Western Hotel, or Thomas building, remains a local landmark. The hotel, built in 1827, was modified over the years to create storefronts on the building's first floor. There are now apartments where once there were hotel rooms. By 1939, the Pearis Theater had replaced the frame buildings shown in the earlier photograph. (GCHS.)

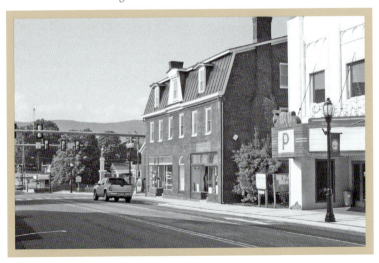

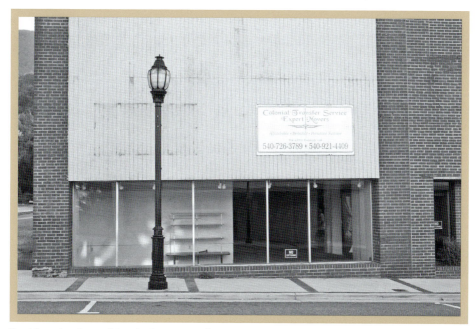

Pearisburg Lumber and Supply Company is shown on Main Street across from the R. M. Ingram Furniture Store in 1946. According to a *Radford News Journal* caption from the time, the store, owned by C. L. Ingram, C. E. Moran, and C. H. Ingram, "offered its customers the best in all kinds of building materials including plumbing and heating equipment." The building was home to Colonial Transfer Service until 2010. (GCHS.)

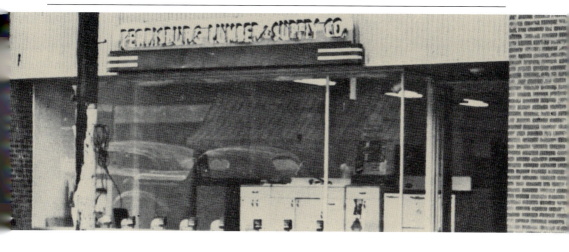

The R. M. Ingram Furniture Store was organized in 1943 on Main Street in Pearisburg to serve Giles and the surrounding counties. Its motto was "Everything to Make the Home Comfortable." Though the building changed throughout the years as the front door was moved and the facade stuccoed, the business remained the same until 2009. A mural, sponsored by Giles Arts Council, has been painted on the right side of the structure welcoming visitors to Pearisburg. (GCHS.)

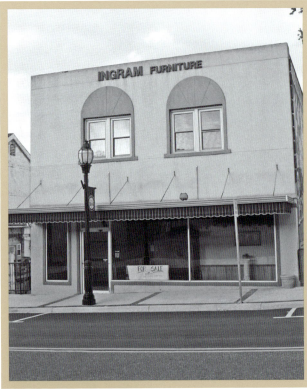

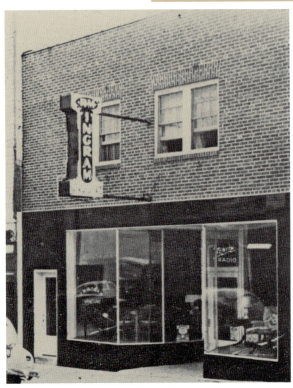

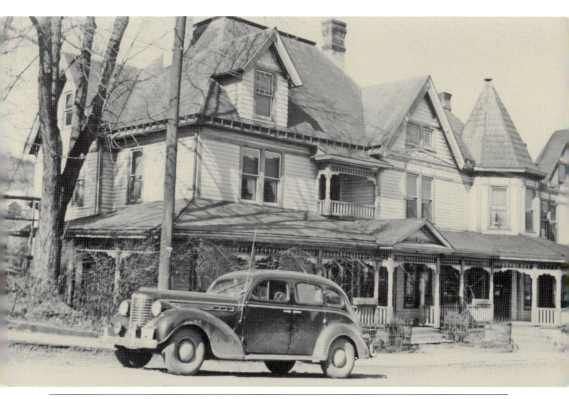

The Savoy Hotel, shown here in 1937, once occupied the southern end of the first block of South Main Street in Pearisburg. The hotel was purchased by the Witten family in 1912 and provided overnight accommodations to out-of-town guests as well as lunch to locals until 1946. The building was razed in the 1960s, leaving an empty lot beside the former Colonial Transfer Service building. (GCHS.)

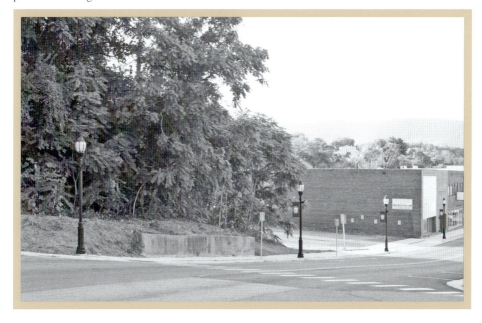

CENTRAL GILES: PEARISBURG TO POPLAR HILL

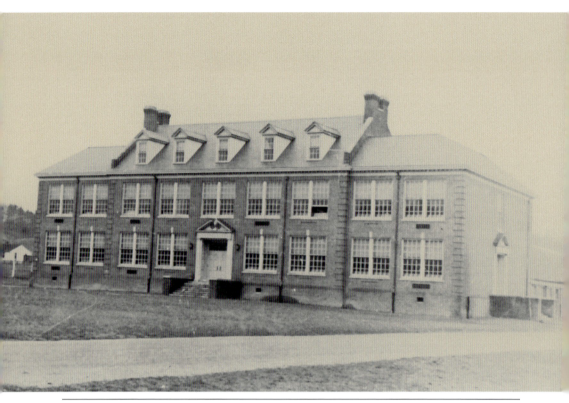

Pearisburg High School, a 1939 WPA project, is shown in a photograph from the 1944 *Peariscope* yearbook. The school was home to the Pearisburg Red Devils until Giles High School consolidated students in the eastern and central parts of Giles County in 1961. The building remained in use as a middle school until 1980, when students were moved to Macy McClaugherty Elementary Middle School. Today the building and grounds are busy with programs almost daily as the Pearisburg Community Center. (GCHS.)

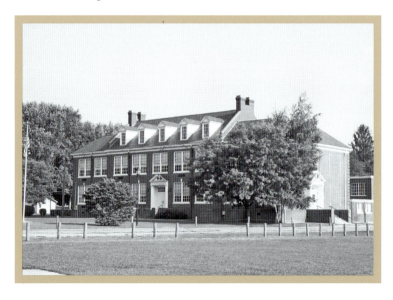

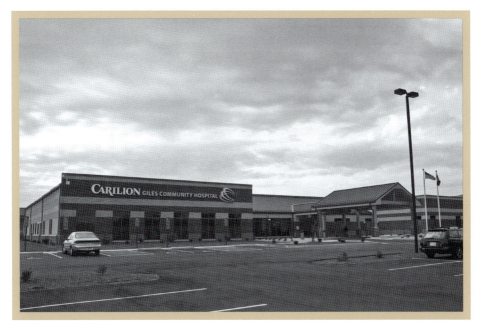

Giles Memorial Hospital opened in 1950 in the Fort Branch area of Pearisburg, replacing St. Elizabeth's Hospital on Wenonah Avenue, completed in 1924. On May 22, 2010, Carilion Giles Community Hospital, located on the hill behind the Pearisburg Walmart, began service as a 25-bed critical access facility with much-improved diagnostic facilities. The new lobby features a mural of Giles County's natural beauty painted by local artist Robert Tuckwiller. (CGT.)

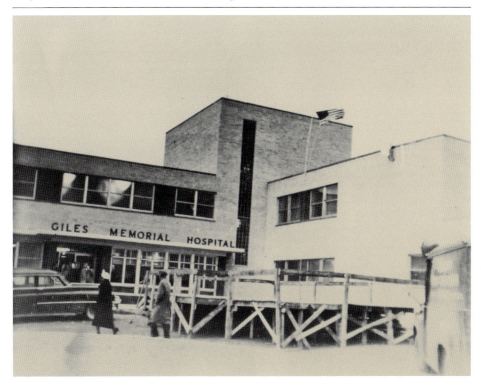

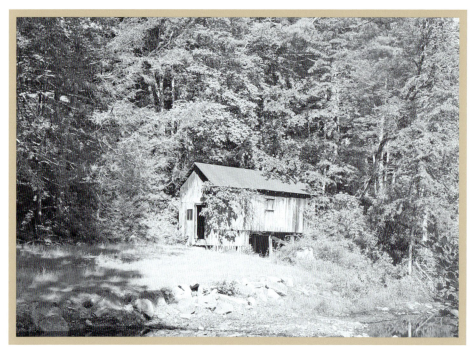

Glen Alton, now a 304-acre U.S. Forest Service property in the Jefferson National Forest, was a farm and vacation retreat from the 1930s through the 1980s. Because of its location in the forest, the site was self-sufficient, with the gristmill shown later becoming the powerhouse. Glen Alton has recently undergone restoration, and the beautiful site is a day-use area open to the public for hiking, bird watching, and even wedding receptions. (Then, USFS; now, Sheryl Lyles.)

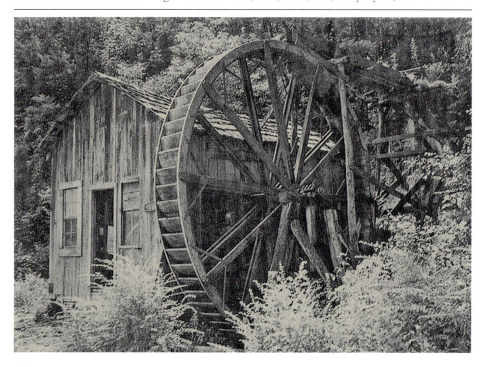

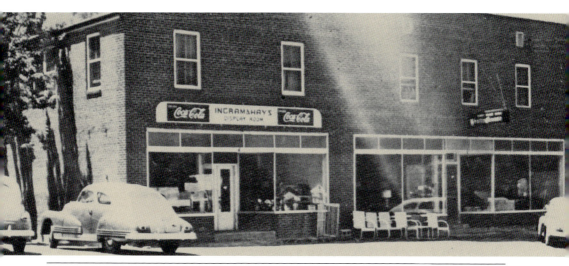

Customers from throughout the county patronized the Ingram and Hays Furniture Company, shown in Bluff City in 1946. The store, carrying furniture and Westinghouse appliances, was managed by C. L. Ingram with partners S. R. Hays and L. P. Ingram. Recently an auto parts store, the building now houses the Giles County Christian Mission store on the ground floor and apartments above. (GCHS.)

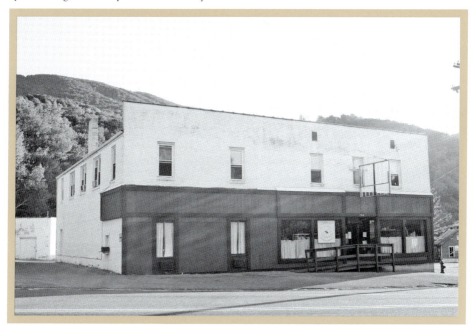

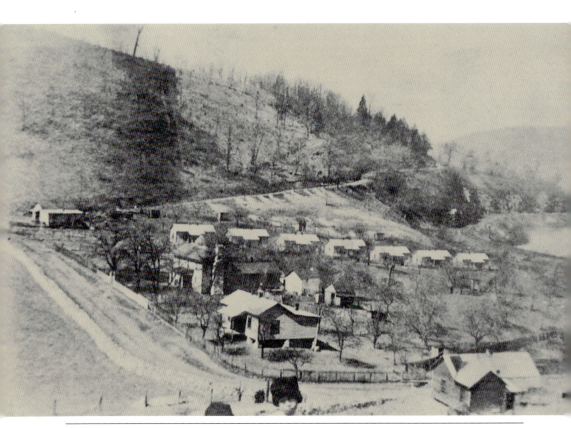

Rental houses for workers at the Leas and McVitty New River Tannery in Bluff City could be seen from the Pearis Cemetery. The houses, on the former W. H. Thomas farm, were built by 1914 between the old main road, Route 100, and the New River. Just one house, shrouded by trees, remains today on Route 100 in this area. Today's view from the Pearis Cemetery shows the concrete plant that fills most of the area today. (GCHS.)

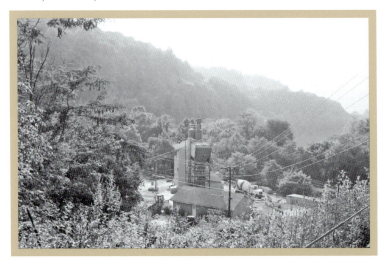

CHAPTER 3

WESTERN GILES
Narrows to Glen Lyn

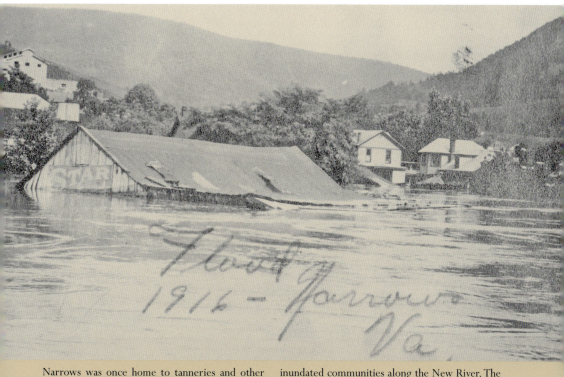

Narrows was once home to tanneries and other businesses attracted by the waters of Wolf Creek and the New River. Until Claytor Dam was completed in 1939, floods such as the one shown in downtown Narrows in 1916 routinely inundated communities along the New River. The New River today is known for beautiful scenic views and fishing, rafting, and other outdoor opportunities. (GCHS.)

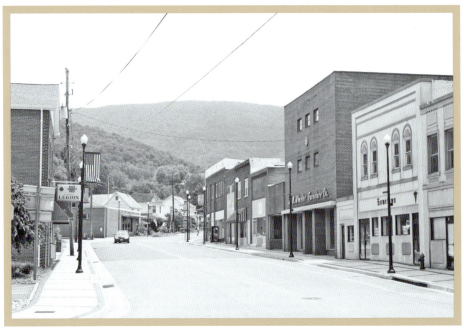

Main Street in Narrows is bustling in the 1950s photograph taken prior to the fire in Wheeler's Appliances and Furniture store. The structure was quickly rebuilt and is the brick A. M. Wheeler Furniture building visible in the later photograph. The other structures on that side of the street remain, though some experienced facade renovations during the downtown revitalization completed in 2000. (CGT.)

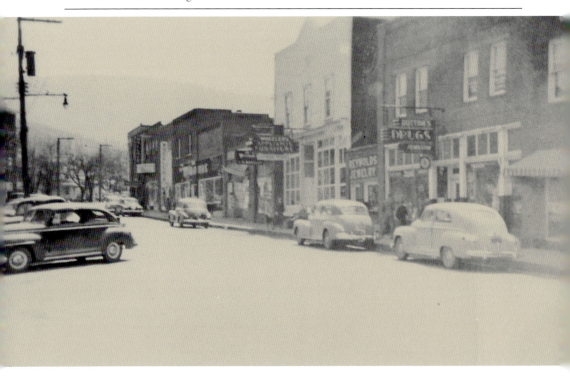

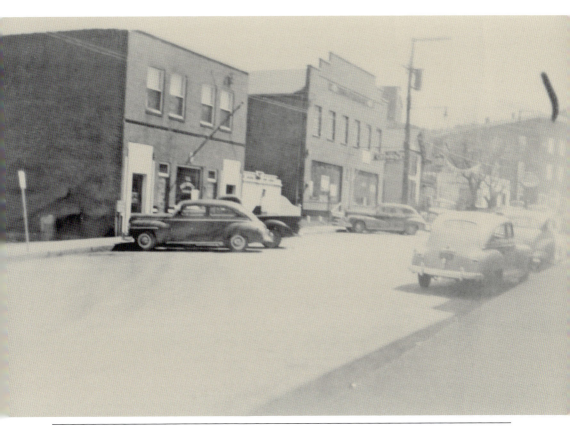

Some of the buildings have changed in this 1950s view of Main Street in Narrows. Today's American Legion building in the foreground housed the post office. The three-story structure in the background of the older photograph was the Masonic Lodge and Odd Fellows Hall, now the location of the post office. The site of the old Esso station is now the new post office's parking lot. (CGT.)

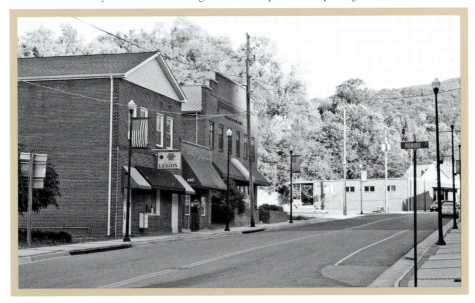

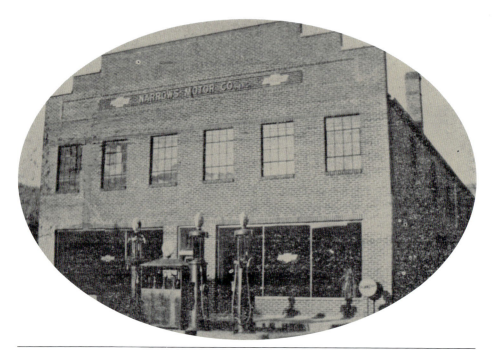

Narrows Motor Company on Main Street was a Chevrolet dealership and Texaco gas station when this photograph was taken around the time it opened in 1930. According to the *Giles County Industrial Survey*, the building featured "model showrooms, elegantly furnished conference rooms, up-to-the-minute garage and wrecking services, and a whole storeroom of accessories." In 1997, the structure was renovated as the Giles Business Incubator. Since 2004, the Giles County Department of Social Services has occupied the second floor. (GCHS.)

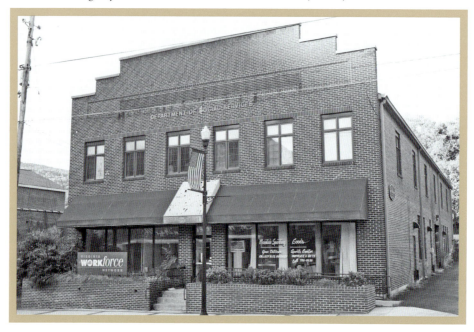

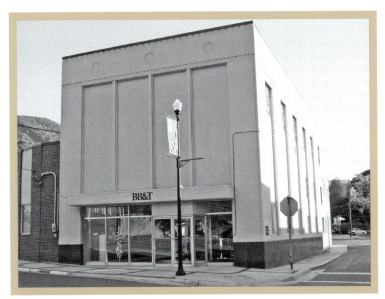

The First National Bank of Narrows was organized in 1905 as the First State Bank of Narrows and became a national bank in 1919. The bank's motto was "As strong as the mountains that surround it." The building shown was constructed on Main Street in 1940, with an addition made in 1953. The bank became a BB&T branch in 2003 and still serves area customers. (GCHS.)

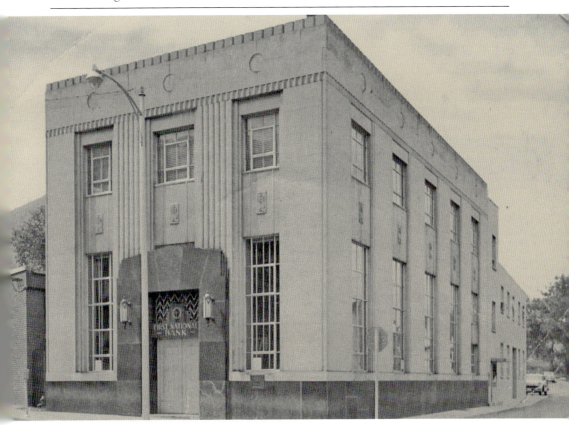

Western Giles: Narrows to Glen Lyn

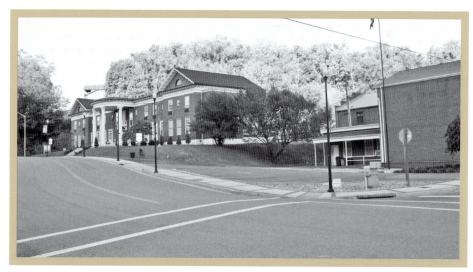

The MacArthur Inn was built in the early 1940s to accommodate business travelers visiting the Celanese Acetate plant in Narrows. After a naming contest in 1941, the inn is said to have been recognized by Pres. Franklin Roosevelt as the first hotel in the country to be named for Gen. Douglas MacArthur. The hotel has recently been restored and reopened to guests. During the summer months, barbecues and carriage rides are offered for local residents and guests on Saturday nights. (CGT.)

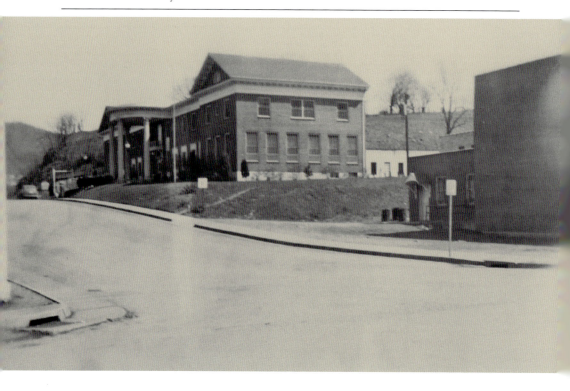

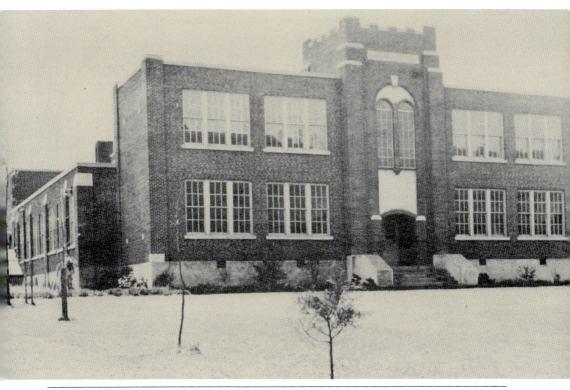

Narrows High School is shown in a photograph from the 1939 *Narrosonian* yearbook. The school, built in 1931, was used until 1961, when a new Narrows High School was built across the river. The old building is now a community center and houses police and recreation department offices. The Narrows Green Wave football team still plays on the old high school football field on Friday nights in the fall. (GCHS.)

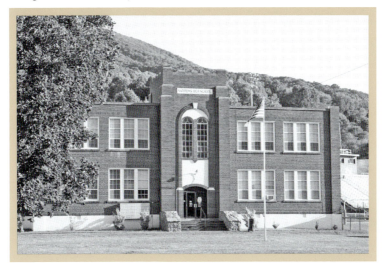

Western Giles: Narrows to Glen Lyn

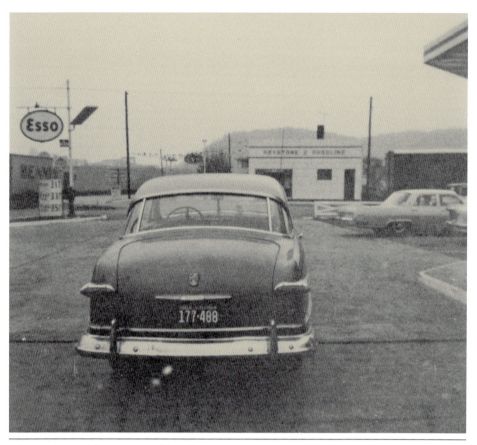

Taken in front of the Esso/Humble Oil station on U.S. 460 in Narrows in 1964, the older photograph is notable for its gas prices—around 31¢ per gallon. Just the roof of the Esso station can be seen in the early photograph, but it remained an Exxon station until 2010 and now is home to Auto Specialty Care, in the foreground of the newer photograph. In the background is the Keystone Gasoline station, now Harvey's Flooring and Feed. (JTF.)

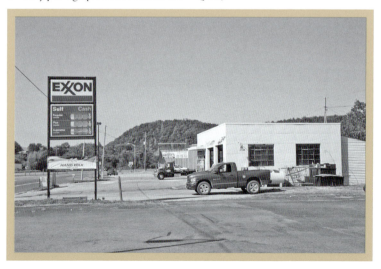

Johnny's Tall Boy, owned and operated by J. T. Frazier, was a fixture at the intersection of U.S. 460 and Route 61 in Narrows from 1971 to 2003. The restaurant featured good home cooking at reasonable prices and was a favorite of Celco plant employees as well as locals and travelers. Menus still visible inside offer pimento cheese sandwiches and pinto beans and cornbread for lunch and country ham and eggs and steak biscuits for breakfast. (JTF.)

In Narrows, the falls of the New River drop 7 feet in 50 feet of river at the location of an old mill, creating both a scenic view from U.S. 460 and Lurich Road and a dangerous spot for boaters. The New River is thought to be among the oldest in the world and flows from south to north from Ashe County, North Carolina, merging with the Gauley River in West Virginia to form the Kanawha River. (CGT.)

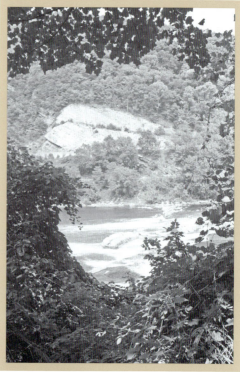

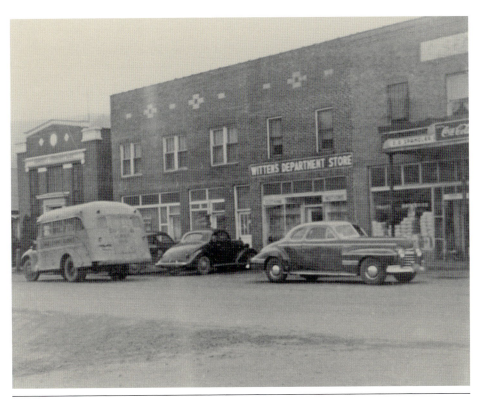

Businesses near the U.S. 219 intersection with old U.S. 460 (Old Virginia Avenue) in Rich Creek included, from left to right, Farmers and Merchants Bank, Mac McClaugherty Barber Shop, Blondie Ganoe's Beauty Shop, Witten's Department Store, and O. O. Spangler's Grocery Store. Enterprises still fill many of these buildings today and include Ike's Barber Shop and an eclectic antique and home decor shop. (RC.)

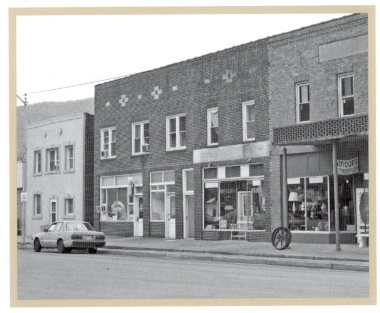

Western Giles: Narrows to Glen Lyn

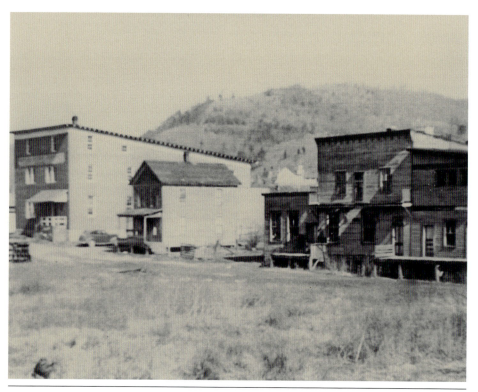

The buildings shown are behind Old Virginia Avenue on Riverside Avenue in Rich Creek. They are W. O. Woodson Wholesale (left), the Cecil Bradley home (center), and Acie Adair Grocery (right). Today the block is filled with Rich Creek Volunteer Fire Department structures. The three-story W. O. Woodson Wholesale building can still be seen at left. (RC.)

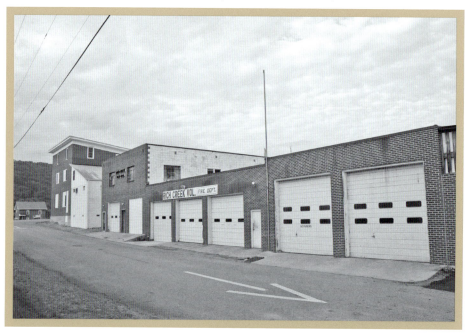

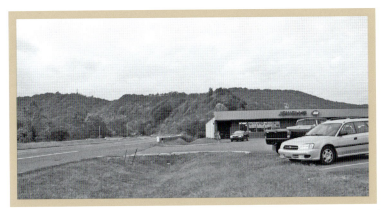

The Virginian Railway ran on the east side of the New River from the time of its completion in 1909 until the 1960s, when its merger with Norfolk and Western was complete and a bridge was built east of Narrows to connect the tracks. The old Virginian Railway right-of-way was used to widen U.S. 460 between Narrows and Glen Lyn in 1972. The Virginian Railway Depot in Rich Creek was located where IGA Jewel's stands today. (RC.)

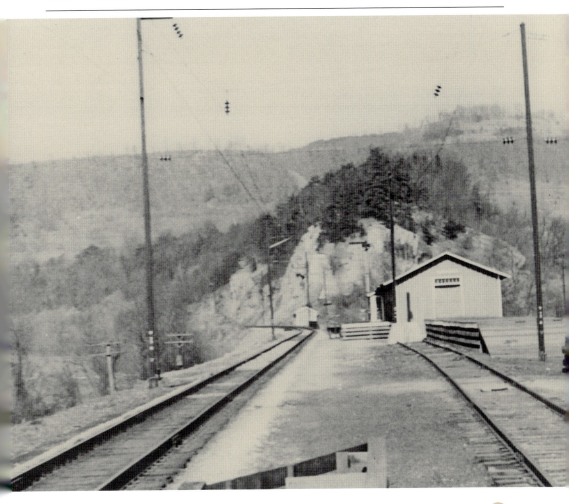

WESTERN GILES: NARROWS TO GLEN LYN

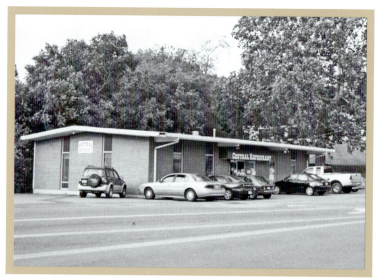

The Riverview Café was located at the busy intersection of Old Virginia Avenue (old U.S. 460) and U.S. 219 in Rich Creek. The restaurant was owned by Deck Spangler. After the café burned to the ground, the Central Restaurant, featuring home cooking, was built in its place. (RC.)

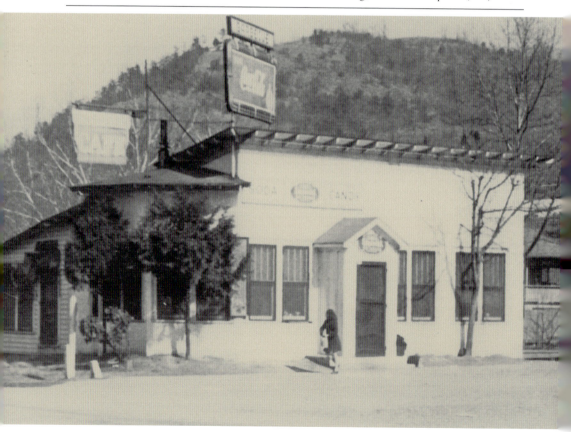

CHAPTER 4

MOUNTAIN LAKE HOTEL

Resort Getaway

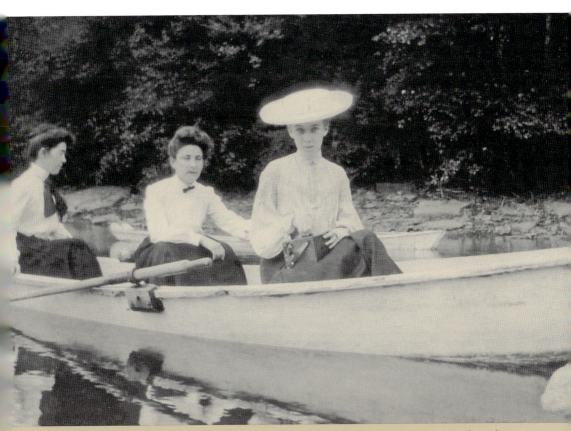

With one of two natural freshwater lakes in Virginia and cool summers at an altitude of nearly 4,000 feet above sea level, Mountain Lake Hotel has attracted visitors since 1856. Outdoor activities and relaxation are just as popular today as they were in 1890, when this photograph was taken. (GCHS.)

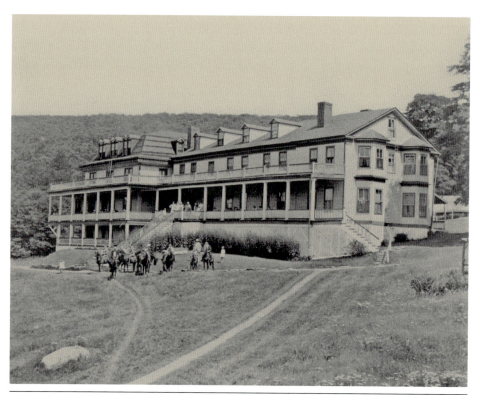

Mountain Lake Hotel has long been a resort attracting visitors from miles away. The lake, discovered by Christopher Gist in 1751, provided a natural attraction. Additions and expansions created the hotel shown here in 1929, but the original structure, built in 1856, can be seen in the center of the building. The old lodging was replaced in 1936 by William Lewis Moody, whose family still retains ownership through the Mary Moody Northen Endowment. (GCHS.)

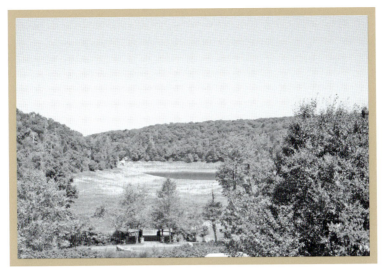

Mountain Lake is fed by springs and groundwater from the surrounding mountains. The basin of the lake is made of various rock substrates, and their fault lines, or cracks, continually let water flow out of the lake. Historically, the lake level has fluctuated in dry times, when more water flows out than in. In 2008, when the lake was dry, the remains of Samuel Ira Felder, a guest from New York who fell overboard while boating in 1921, were found. (GCHS.)

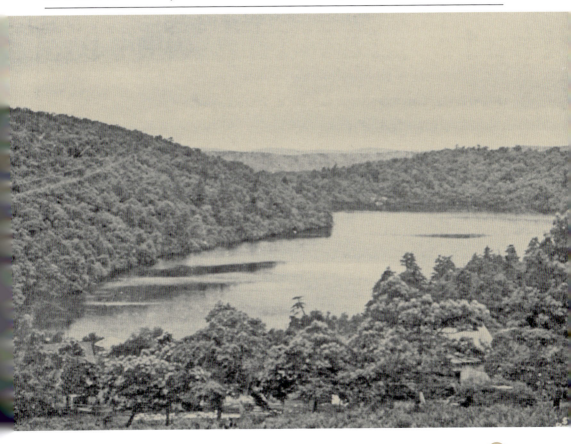

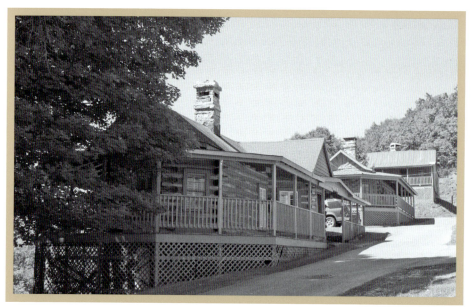

Three cottages, Valley View, Sunset, and Cayford, are visible along the road to the old golf course. Beginning in the 1910s, frequent visitors were allowed to build cabins at Mountain Lake. Valley View was built by the Moody family of Galveston, Texas, and Sunset was built by Dr. George Warren of Richmond by 1918. James Branch Cabell, an author of ironic fantasy, built Cayford in 1923. Visitors still stay in these cottages today. (GCHS.)

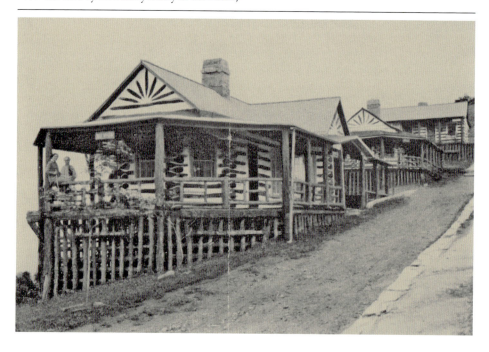

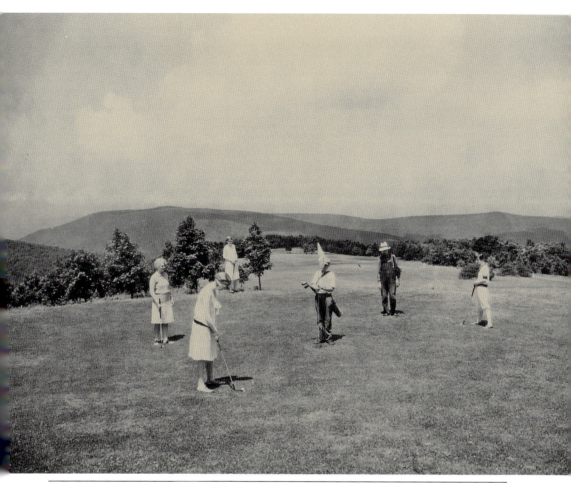

The 9-hole golf course at Mountain Lake was completed in 1917 and at the time was billed as "the highest course in the United States East of the Rockies." Located about a mile from the hotel, the course was accessible by horseback, buggy, or car. Comparing the 1929 view to today's view shows that little has changed except that, with disuse, the old golf course has become a meadow. (GCHS.)

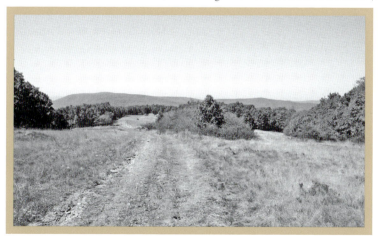

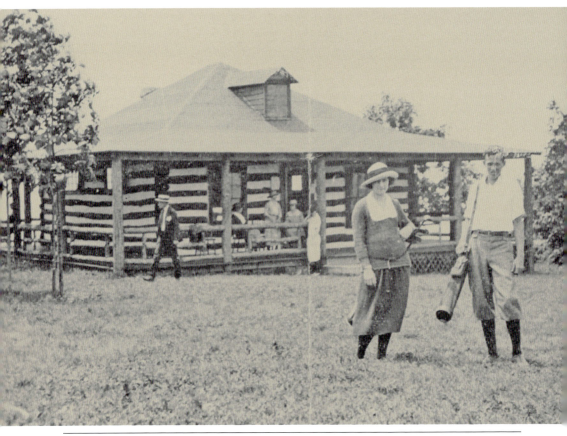

The original golf clubhouse was built on Prospect Rock in 1917 of chestnut logs with hardwood floors and a large rock fireplace. It was replaced in 1937 with a stone structure to match the new hotel. On the edge of a cliff over 4,000 feet above sea level, the building retains a commanding view of the valley below. A brochure boasted of being able to see mountains in five states from the clubhouse. (GCHS.)

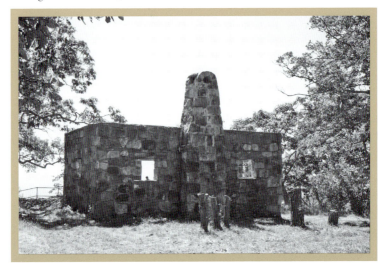

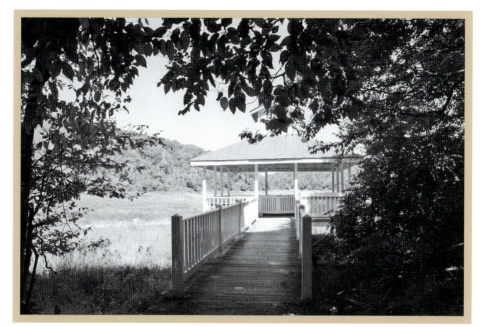

Boating, fishing, and swimming are always popular at Mountain Lake when the water level is high, despite the cold water. In the past, the boat dock was located nearer the hotel than it is today. Because the water level is so low, a temporary boat dock was placed closer to the water allowing visitors to enjoy the lake in the summer of 2010. (GCHS.)

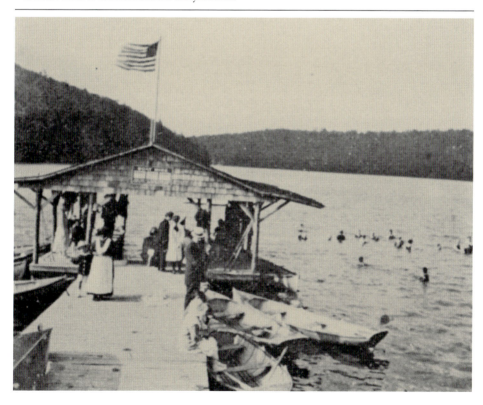

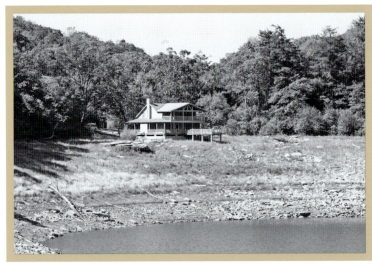

The Lakeside Club House, at the northern end of Mountain Lake, was built in 1931. The clubhouse offered boat rentals, snacks, and swimming on the opposite end of the lake from the hotel. Today the building is rented to guests as the four-bedroom Newport House. It still features its own dock, usable when the lake level is higher. (GCHS.)

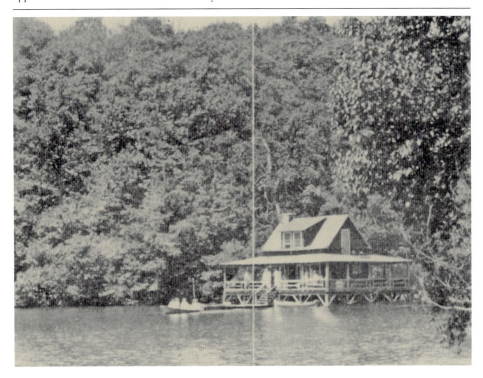

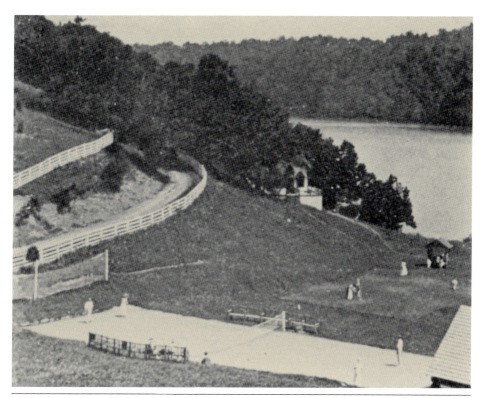

A regulation concrete tennis court and a croquet court were built at Mountain Lake in 1931 as part of the many amenities to attract guests. Today, in addition to tennis, there are a life-sized chess game, volleyball and badminton nets, a putting green, a pool, and other activities to complement hiking, mountain biking, and orienteering opportunities. Visitors can "do it all or nothing at all." (GCHS.)

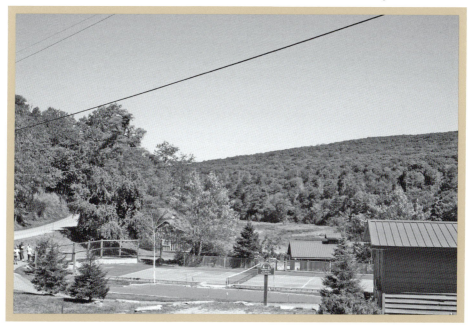

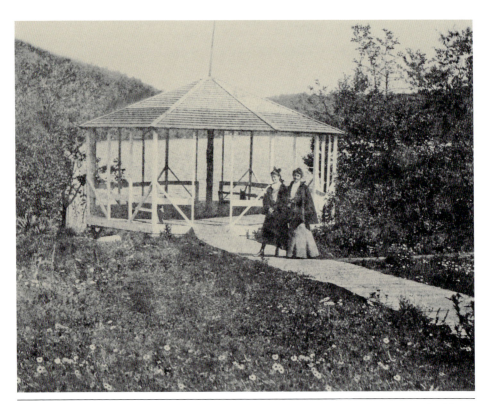

An 1875 photograph shows two women enjoying the cool mountain air at Mountain Lake's gazebo. The structure has changed throughout the years, but the gazebo at Mountain Lake has long been a popular place for visitors to view the lake or couples to wed. Several scenes from the movie *Dirty Dancing* were filmed at the gazebo, which is still visible today. (GCHS.)

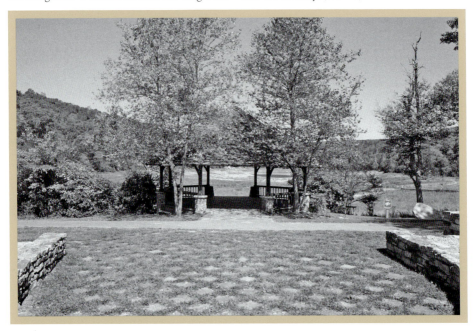

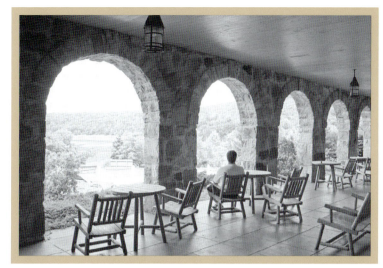

The porch at Mountain Lake Hotel changed when the new sandstone hotel was built in 1936, but the view to the lake remains the same. Mountain Lake sits on rock substrates with fault lines that enable water to flow out of the lake at rates of up to 600 gallons per minute. In years with little rainfall, the water level drops. In 1929, the lake level was much higher than it is today. (GCHS.)

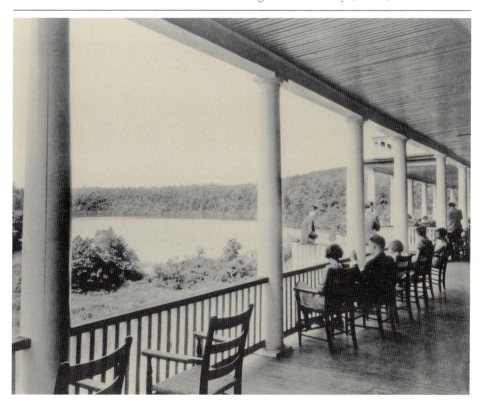

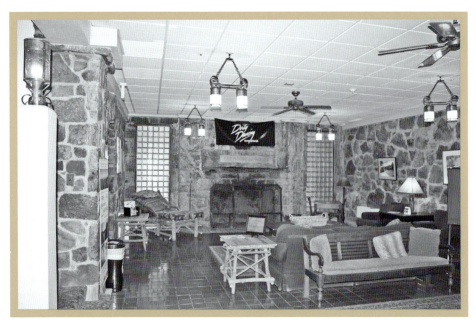

The lobby of Mountain Lake Hotel is shown in 1959. "The House of Moody" on the mantle refers to William Lewis Moody, who built the present stone hotel in 1936. Today a banner for *Dirty Dancing* is featured on the mantle as well, commemorating Mountain Lake Resort's role as Kellerman's Resort in the 1987 movie starring Patrick Swayze and Jennifer Grey. (GCHS.)

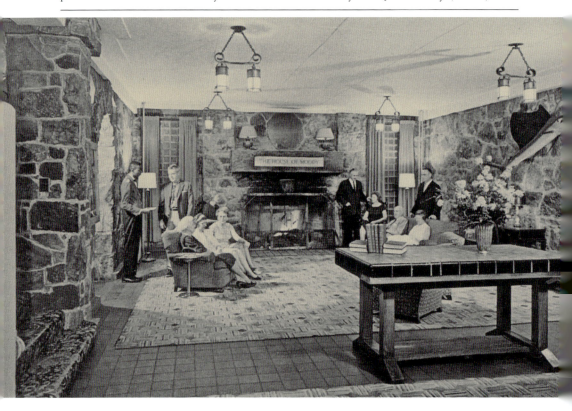

CHAPTER 5

HOMES
Lost and Found

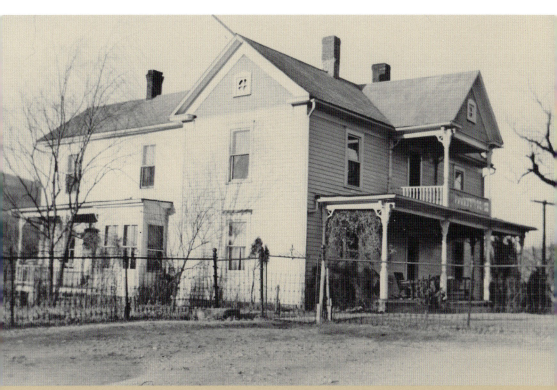

W. H. Thomas, a well-known local business owner, lived in this house in the early 20th century. Located behind the old Wade's supermarket in Bluff City near the railroad and the New River, a section of the house may have been built by George Pearis, for whom Pearisburg is named. The home was restored in 2008. (GCHS.)

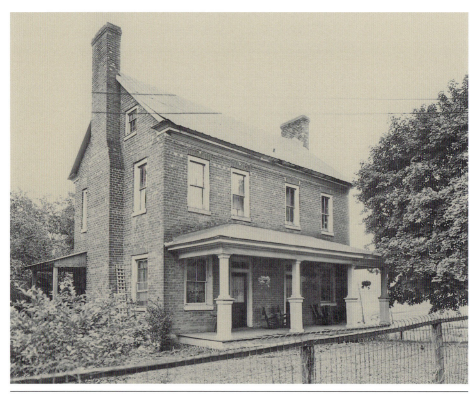

John Toney built his house in Glen Lyn near the New River and the mouth of the East River in 1780, before Giles County was formed. The house was removed when U.S. 460 was expanded to four lanes here near the West Virginia border. Today the site is home to the Glen Lyn Post Office, several businesses, and a memorial to Mary Porter stating that she was "killed by Indians" in 1742. (MT.)

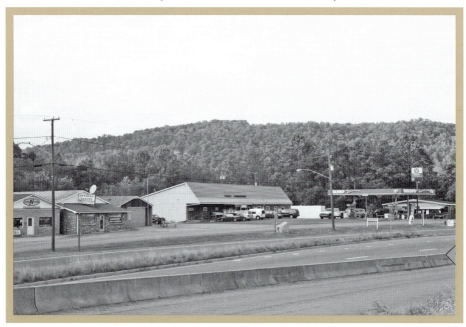

Shown in 1938, the Hoge house, originally to the left of today's Eastern Elementary School, was built in the 1840s by Capt. Joseph H. Hoge. The residence was lost to fire during restoration work. At present, 130 acres of Hoge farmland is being developed as Wheatland EcoPark, an industrial park where all buildings must qualify for U.S. Green Building Council LEED certification. The first tenant is NanoSonic, which opened there in September 2010. (GCHS.)

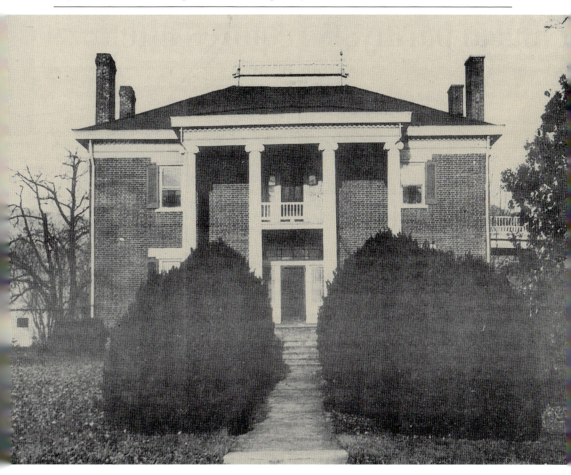

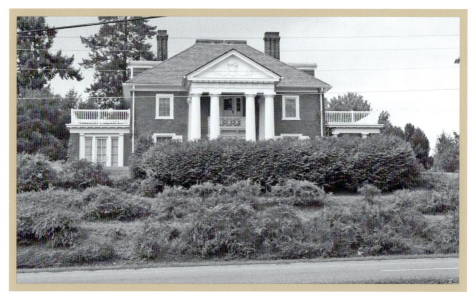

The home built for the family of Anderson Shumate, a banker and legislator, is located across Wenonah Avenue in Pearisburg from the site of judge Bernard Mason's residence. The brick wall and steps to the street have been removed, but otherwise, the house, sitting above the street, is just as eye-catching today as it was when the earlier photograph was taken in 1937. (GCHS.)

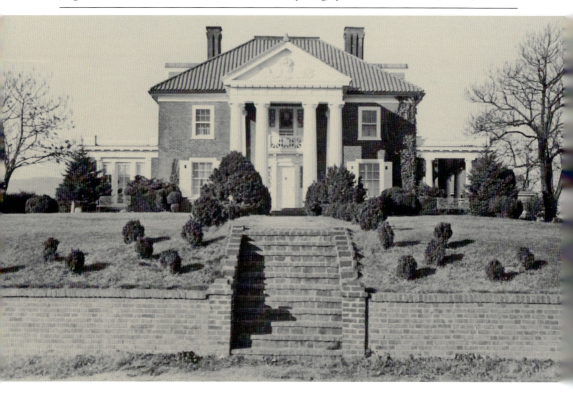

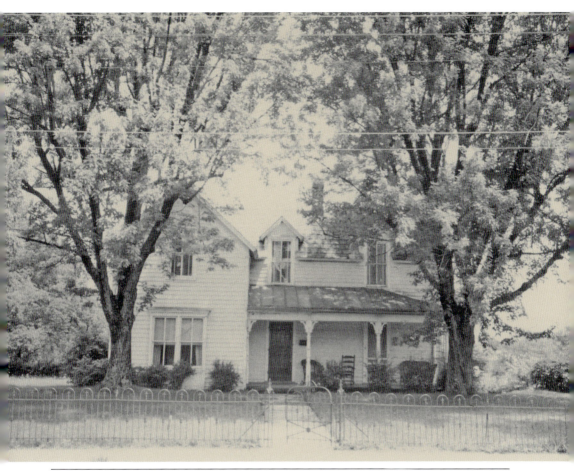

Main Street and Wenonah Avenue in Pearisburg were once lined with stately residences that were home to the many businesspeople of the town. A number of these houses were lost to progress, as businesses bought the prime real estate for new buildings. Stellar One Bank on Wenonah Avenue is located where this home once stood. (GCHS.)

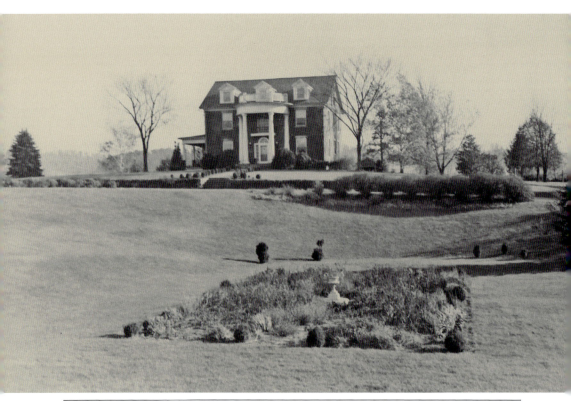

The prominent home of Judge Bernard and Margaret Mason was located on a 2-acre site on Wenonah Avenue when this photograph was taken for the Pearisburg Woman's Club scrapbook in 1936. The beautiful landscaping of the Mason property stands in stark contrast to the Save-A-Lot, Dollar General, and Bahama Sno-Shack that are located on the property today. (GCHS.)

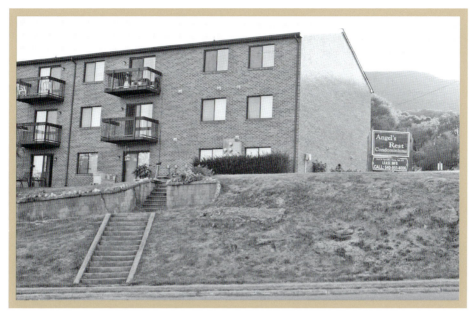

The Pedigo house was located on Main Street in Pearisburg just south of the Savoy Hotel. When this photograph was taken in 1938, Main Street and Wenonah Avenue were lined with impressive family homes such as this, creating a decidedly different streetscape than is present today. Angel's Rest Condominiums are now on the site of the Pedigo house; only a retaining wall and steps remain. (GCHS.)

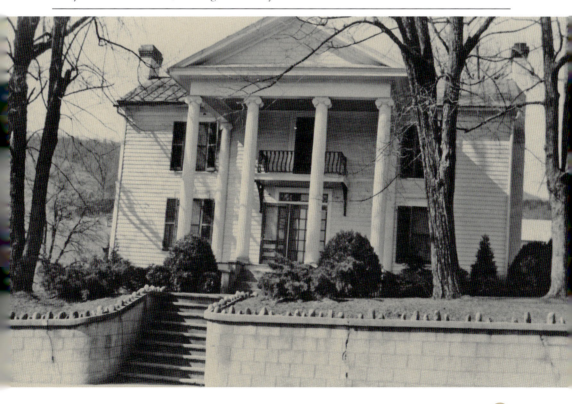

Homes: Lost and Found

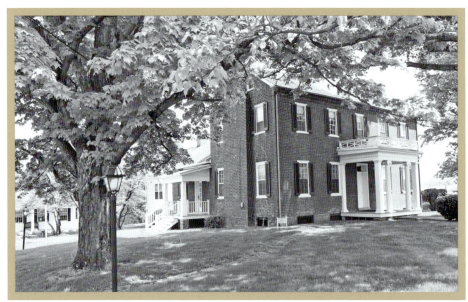

The Andrew Johnston House, shown in 1937, is located on Main Street in Pearisburg and is the oldest brick house remaining in the county. The 1829 home is the centerpiece of the Giles County Historical Society's museum complex. Just visible to the left in the old photograph is the doctor's office where H. G. Johnston I and II practiced medicine and which was occupied by Rutherford B. Hayes and William McKinley as a Union headquarters for several days during the Civil War. (GCHS.)

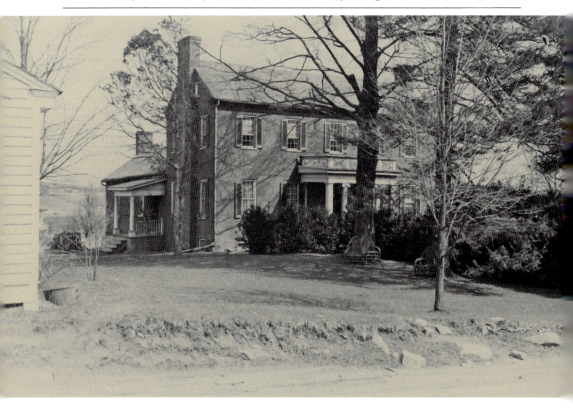

CHAPTER 6

INDUSTRY

From Mills to Factories

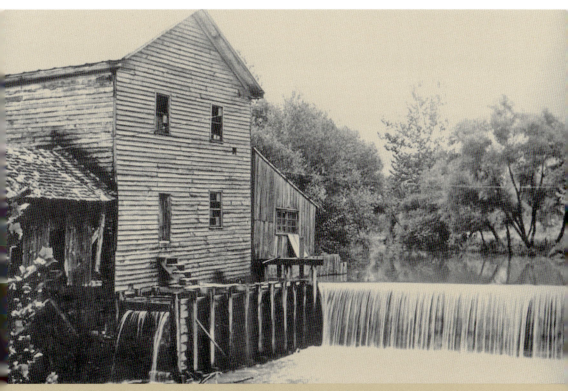

Zell's Mill, a flour and gristmill and vertical sawmill on Sinking Creek near Newport, is shown in 1937 and was a typical sight in early Giles County. People took advantage of the waterpower provided by the New River and creeks to meet their basic manufacturing needs. Few traces of these mills are left today. (USFS.)

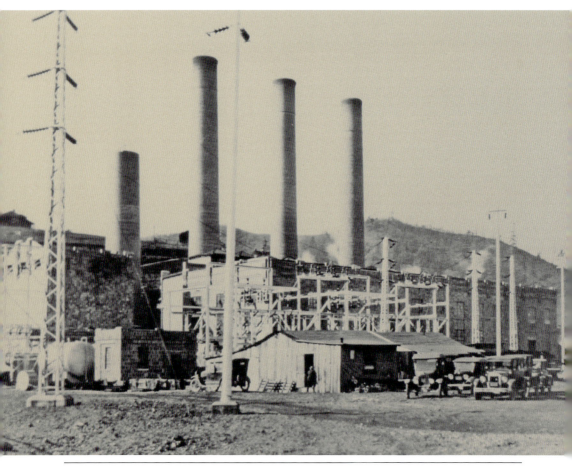

Located on the New River in Glen Lyn and highly visible from U.S. 460 near the West Virginia state line, the Appalachian Power plant has generated electricity and employment since 1919. A fourth stack had just been added, increasing power output, when the earlier photograph was taken. Now the facility is much larger, but it has been put into extended startup status in 2010, to run only during times of peak electricity demand. (GCHS.)

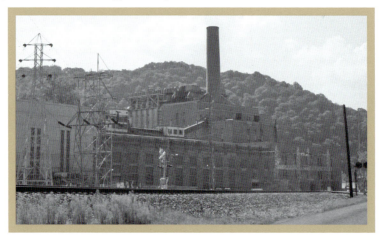

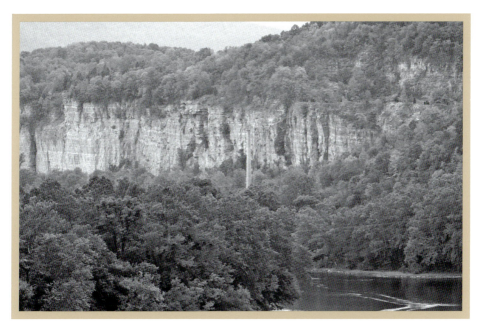

At one time, there were a number of limestone quarries in Giles County. The Virginian Limestone Corporation facility at Klotz across the New River from Ripplemead was located not far from today's Chemical Lime plant in Kimballton. Virginian Limestone Corporation opened in 1916 to supply ballast for the Virginian Railway. Today the smokestack at Klotz is still visible from the U.S. 460 Bridge at Ripplemead, but little else remains. (GCHS.)

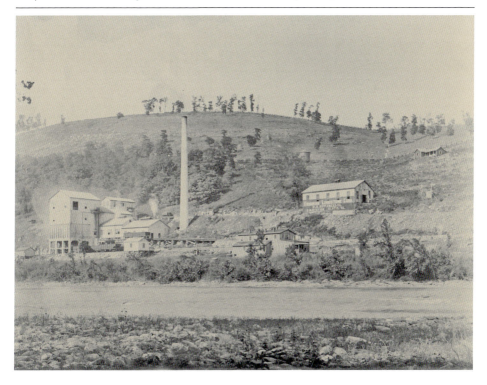

Industry: From Mills to Factories

A view from the Pearis Cemetery shows the size of the Leas and McVitty New River Tannery in Bluff City. The tannery opened in 1895, employing many in the area in the manufacture of heavy sole leather for shoes and boots. A 1976 fire burned the buildings, leaving only the old water tower, barely visible at left in the overgrowth, to mark the tannery's location. The property is now used by the Giles County Public Service Authority. (GCHS.)

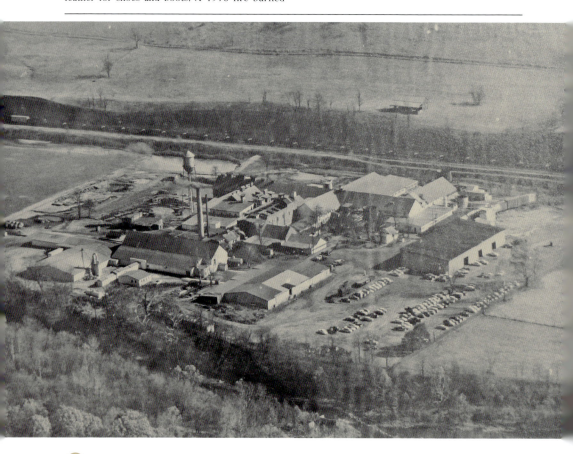

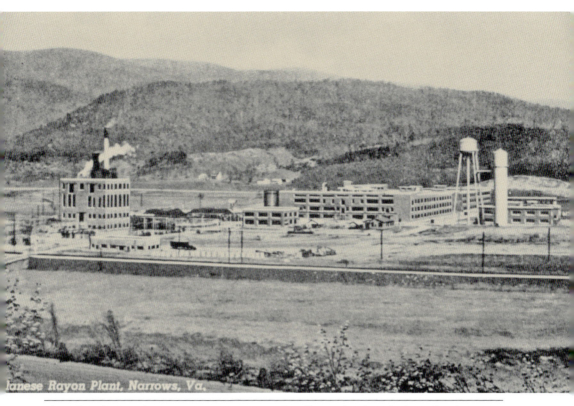

lanese Rayon Plant, Narrows, Va.

The Celco Plant on the New River in Narrows began production on Christmas Day 1939 and had 869 employees by 1940, when the older photograph was made. The plant made Celanese acetate fiber to be woven into cloth, a substitute for silk popular through the mid-20th century. At its peak, the factory employed 4,600 people. Today it produces cellulose acetate flake and tow and employs about 20 percent of its peak workforce. (GCHS.)

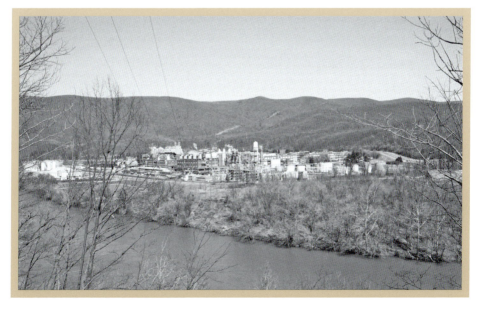

The American Block Plant in Rich Creek manufactured concrete blocks and occupied the former Duncan Implement Company Store. The facility was located at the corner of Old Virginia Avenue (old U.S. 460) and Woodland Road at the site of the current VB Mart and Marathon gas station. The block plant later moved to a site across from where the Methodist church now stands. (RC.)

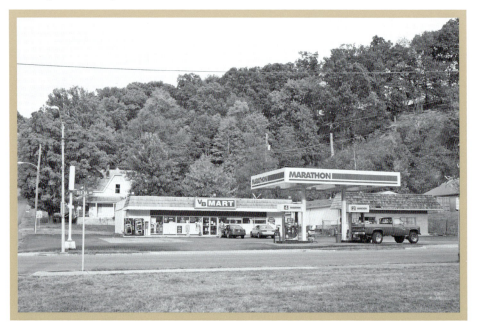

CHAPTER 7

BRIDGES

Crossing Water

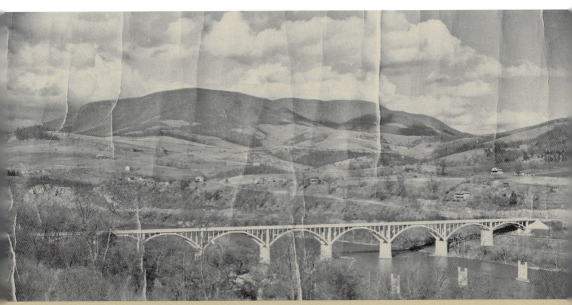

The second bridge across the New River at Ripplemead was completed in 1935, replacing an earlier span built in 1899. At the time of its construction, the bridge had the longest concrete arch span of any bridge in Virginia. It was replaced in 1974 during the widening of U.S. 460 to four lanes. (GCHS.)

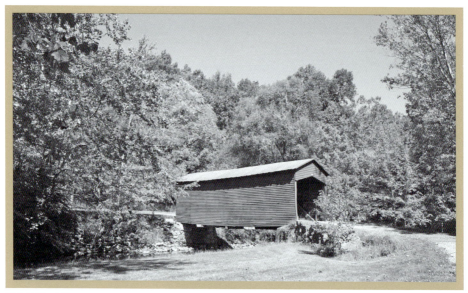

The Link Farm covered bridge, built in 1912, is located on Route 700, Mountain Lake Road, near Newport. One of three covered bridges in Giles County, the 50-foot span crosses Sinking Creek. Travel on Route 700 today crosses Sinking Creek on a concrete bridge built in 1949. Though today on private property and unsafe for vehicular travel, the bridge creates a scenic vista for travelers to Mountain Lake. (GCHS.)

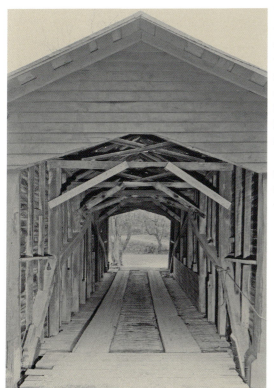

Without a roof, wooden bridges would typically last less than 10 years due to the effects of moisture and weathering on wood. By adding a roof, a covered bridge may last 80 years or more. A view of the north portal of the Link Farm covered bridge shows the truss structure that has helped the bridge maintain its integrity for almost 100 years. The bridge, at just 12 feet wide, is the narrowest of the nine remaining covered bridges in Virginia. (HAER VA-126.)

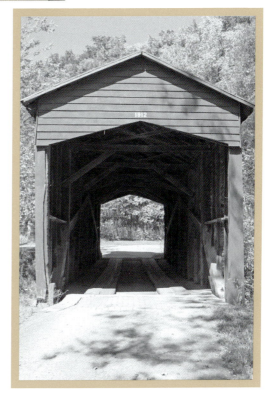

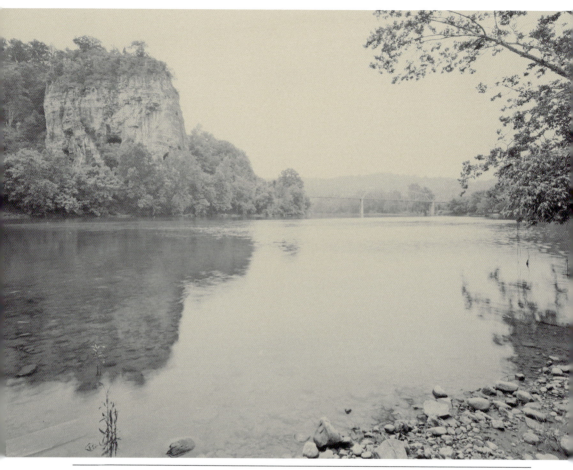

Castle Rock on the New River at Pembroke is a picturesque limestone formation that lends its name to many businesses in the area. Eastern red cedar trees on the top of Castle Rock are thought to be over 500 years old. A railroad tunnel cuts through Castle Rock nearer river level. Except for tree growth on the river's edge, the view to Castle Rock has changed little over the years. (HAER VA, 36-PEMB.V.)

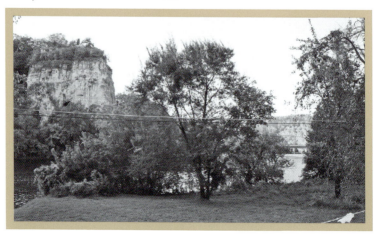

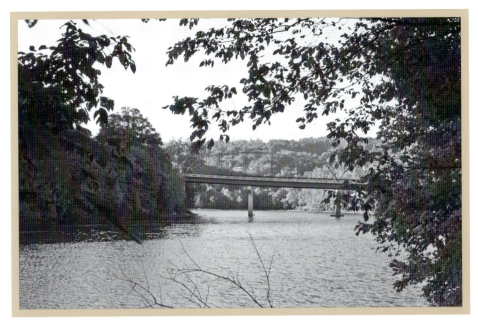

The New River crossing at Castle Rock at Pembroke was once an important ferry crossing for visitors to Mountain Lake Resort. An iron truss bridge was built in 1916 by the Virginia Bridge and Iron Company of Roanoke. A new span was built in 1996, but the old one remains due to its historic value as one of the few remaining iron bridges in Virginia. (HAER VA, 36-PEMB.V.)

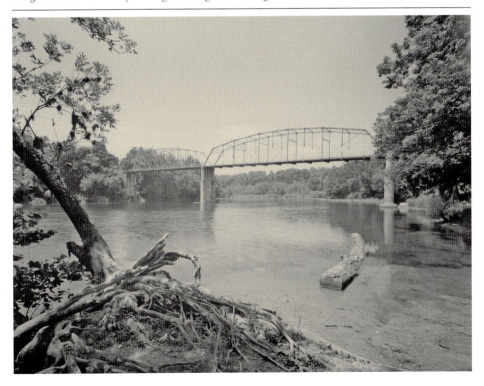

BRIDGES: CROSSING WATER

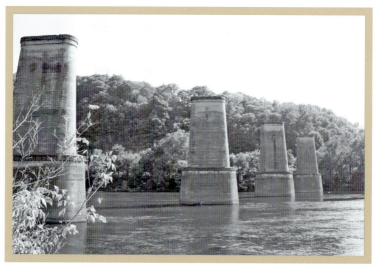

The Virginian Railway, a competitor to the Norfolk and Western Railway, was completed through Giles County on the eastern side of the New River by 1909. The bridge on concrete piers at Glen Lyn was once the highest trestle in the world, elevated above the New River and the Norfolk and Western tracks below. The piers are still visible, becoming shorter as they enter Glen Lyn Town Park. (GCHS.)

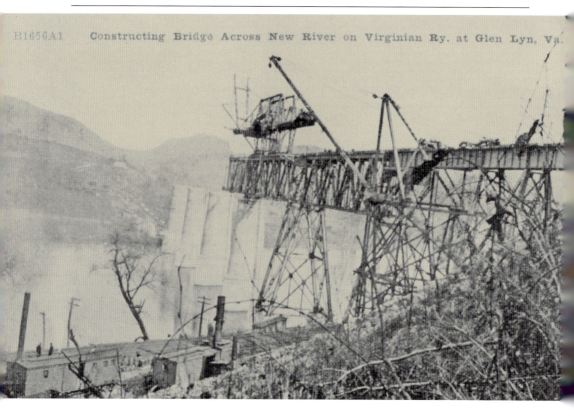

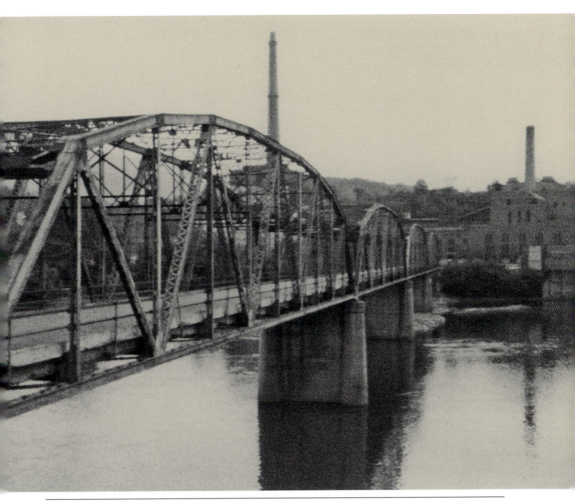

The old U.S. 460 bridge, built in 1930, is shown crossing the New River to the Appalachian Power plant in Glen Lyn. When the highway was widened to four lanes, a new westbound bridge was built in 1969, and the old bridge was used for eastbound traffic. A new eastbound bridge was built in 1986 and is just visible in the right in the now photograph taken from the Glen Lyn Town Park. (MT.)

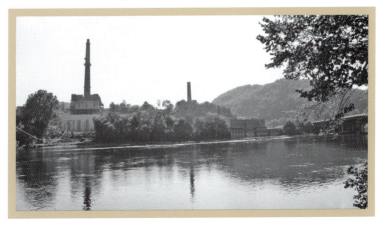

BRIDGES: CROSSING WATER

Replacing an earlier bridge built in 1918, Narrows Memorial Bridge across the New River was built in 1951 at a cost of $500,000. It connects U.S. 460 with downtown Narrows and Route 100 and passes under the Norfolk Southern Railroad tracks. Now reaching the end of its life span, the bridge will continue to carry traffic while it is being replaced at an estimated cost of $15 million. (CGT.)

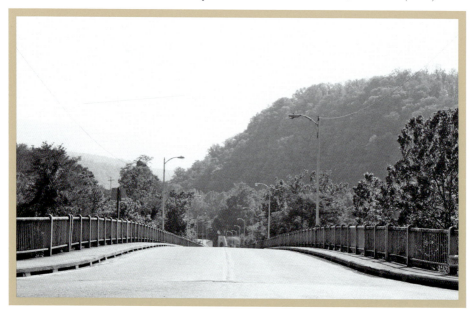

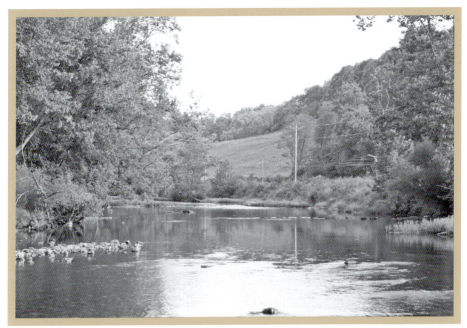

The pedestrian bridge over Walker Creek connected Route 100 with homes on the other side of the creek during periods of high water. The 100-foot-long cable-and-wood bridge, maintained by the Virginia Department of Transportation, collapsed in 2008 under heavy load, dropping 10 people 30 feet into the water below. The bridge has since been removed. (GCHS.)

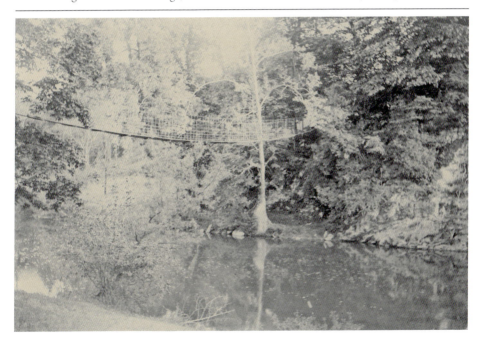

www.arcadiapublishing.com

Discover books about the town where you grew up, the cities where your friends and families live, the town where your parents met, or even that retirement spot you've been dreaming about. Our Web site provides history lovers with exclusive deals, advanced notification about new titles, e-mail alerts of author events, and much more.

Arcadia Publishing, the leading local history publisher in the United States, is committed to making history accessible and meaningful through publishing books that celebrate and preserve the heritage of America's people and places. Consistent with our mission to preserve history on a local level, this book was printed in South Carolina on American-made paper and manufactured entirely in the United States.

This book carries the accredited Forest Stewardship Council (FSC) label and is printed on 100 percent FSC-certified paper. Products carrying the FSC label are independently certified to assure consumers that they come from forests that are managed to meet the social, economic, and ecological needs of present and future generations.

Find Your Place in History.